Bloom

THIS BOOK IS DEDICATED TO MY GRANDPA CLIFF,
WHO WAS ALWAYS THE VOICE OF REASON AND A SYMBOL
OF STRENGTH AND PERSEVERANCE IN MY LIFE.

Bloom

NAVIGATING LIFE AND STYLE

Estée Lalonde

EBURY
PRESS

Preface

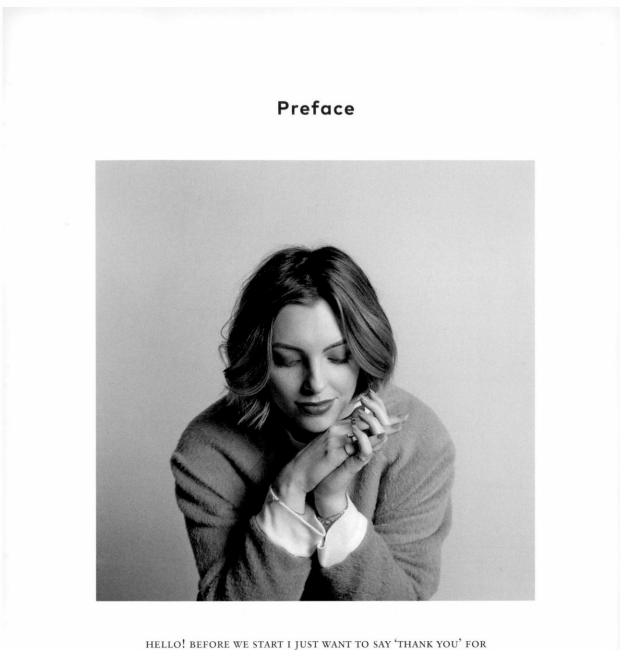

HELLO! BEFORE WE START I JUST WANT TO SAY 'THANK YOU' FOR
HOLDING THIS BOOK IN YOUR HANDS. JUST THE FACT THAT YOU'VE
CHOSEN TO PICK UP THIS ONE FROM THE VAST SEA OF OTHER
WONDERFUL BOOKS MAKES MY HEART GO PITTER-PATTER, SO THANK
YOU FOR CHOOSING TO READ WHAT I HAVE TO SAY.

While writing this book I spent an afternoon reliving a lifetime of memories by going through my 'baby' boxes. I never understood why my mom wanted to keep all of my childhood paraphernalia – homework, little shreds of paper with lists and thoughts of mine, and artwork from over the years – but she would always say with confidence that I would want it all one day. And she was right; that day did come. Among the old photographs and school test results I found a list of things I wanted to do when I grew up and one of those things was 'write a book that sells'. I was an ambitious little seven-year-old. I've always considered myself a determined person, but to see this ambition written down from a time I don't remember was fascinating.

When the opportunity arose for me to write this book my first reaction was, 'Absolutely not!' My underlying feeling was that I was too scared to do something so momentous. I'm scared of everything – even filling up my car with petrol scares me. What if I can't get the gas tank open? What if my card gets declined? What if I don't park my car close enough to the pump? That being said, I like to challenge myself. I feel empowered by the motto 'feel the fear and do it anyway'. So that's why I decided to write this book. I also wanted to make my seven-year-old self proud, and I want to inspire others to take a chance on those things that scare them.

If I let fear dictate what I could and couldn't do, I would be in a very different place to the one I am in now. For one thing, I definitely wouldn't have moved across the world to be with the person I love at the age of 19, and I *definitely* wouldn't have made my first YouTube video for the world to see.

For my friends and supporters, I want *Bloom* to give some insight into the parts of my life that I don't necessarily talk about all of the time, and I want to do it because I owe it to you. I consider this book to be one big thank you letter – I hope it comes across that way.

ESTÉE

Introduction

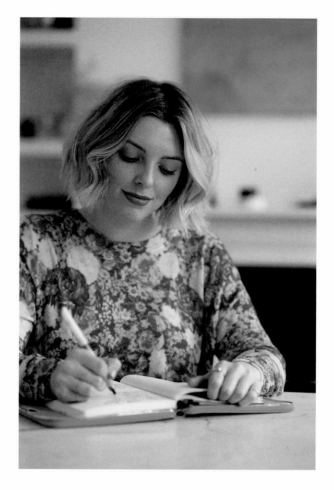

WHEN I WAS TRYING TO THINK OF A TITLE FOR THIS BOOK I WENT BACK AND
FOURTH FOR WEEKS SEARCHING FOR THE PERFECT ONE. THEN ONE SPRING
AFTERNOON I WAS WALKING MY DOG WHEN I NOTICED THE FIRST SIGNS
OF LIFE SPROUTING FROM THE GRASS AND I INSTANTLY THOUGHT, 'BLOOM!
THAT'S IT! THAT HAS TO BE THE TITLE!' IT INSTANTLY FELT RIGHT.

I have always looked forward to the flowers blooming in the spring because it creates an energy in the atmosphere, as if to say, 'The cold months are over – now it's time for some fun!' I've worked very hard to be able to silence the static and tune in to the voice inside my head that is always right when it comes to things like this.

Bloom is the idea that anything is possible when you put your mind to it. I've done a lot of growing up and a lot of changing in a relatively short amount of time, which has been a very interesting journey. I used to look in the mirror and see an unsure, nervous and self-conscious girl staring back at me, but now I see a confident and passionate businesswoman. This book is exploring my 'bloom journey': the journey I went on to blossom into who I've become today, including some of the high and low points that inevitably pop up along the way.

I'll be talking about the things that make me excited to be alive, such as travel, friends and family, as well as beauty and fashion that, to me, are more than meets the eye. I want to express why these things are so meaningful and hopefully my experiences will help others on their own paths. Everyone has their own lane and their own track, and I'm interested in making that journey as fulfilling as possible.

I wanted to write a book that was honest and that people of all ages could relate to. *Bloom* is for teens who are working through their own bloom story now; I know I would have found a book like this helpful when I was younger and I hope that sharing some personal stories will encourage a younger audience to keep doing their best at whatever their passions are. But *Bloom* is also for women who might recognize their younger selves in parts of my journey. Sometimes it can be a wonderful thing to walk down memory lane and give yourself a pat on the back for all of the cool things you have accomplished.

Bloom is a snapshot of where I am now in my life. It's the beginning of a very long journey that I'm so excited to be on. Bloom is where I've been – and I'm looking forward to where I'm going.

One

—

Life

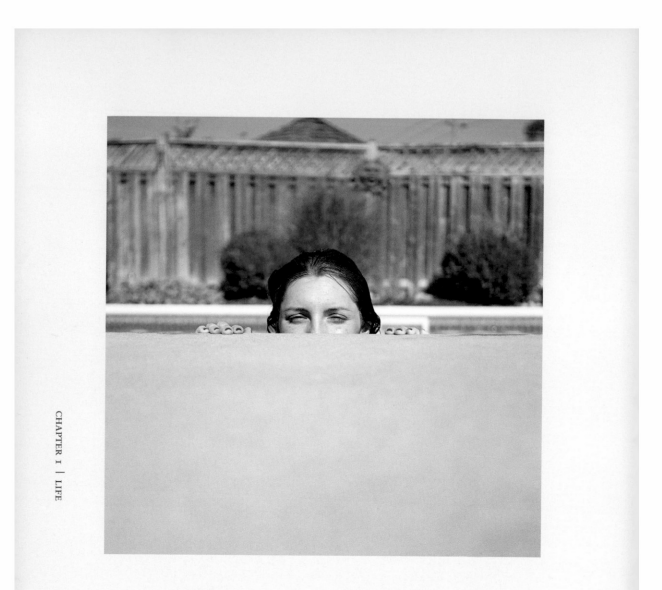

Life is all about balance and I've learned
that if things in my life are unbalanced,
my emotions will be too. I want to live the
kind of life that I look back on and think,
'Well done for doing whatever the hell you
wanted to do.' I want to live a life free
of limitations and filled with happiness.

I am not always a positive and upbeat person, but I focus on trying to be as positive as I can be without ignoring my feelings. I'm convinced that super positive and perky people are all ignoring their inner grumps, whereas I embrace the fact that sometimes it's good to be a moody old bat.

I grew up with my grandparents always being around, which helped shape my outlook on the world; they taught me to take things slow, to stop and smell the roses, and they also helped me see how the little things in life can bring so much joy.

What is happiness anyway?!

Everyone wants to be happy and even if you think you're happy, you want to be happier. What does it mean to be happy? I think everyone feels happiness in different ways.

What makes me happy isn't going to be the same as what makes other people happy, which is why self-discovery is so important. For a long time I tried mimicking the things that made other people happy, such as going out to fancy restaurants or getting dressed up and going to a swanky event, but those things don't make me truly happy. Sure, they're cool experiences, but what about the everyday stuff?

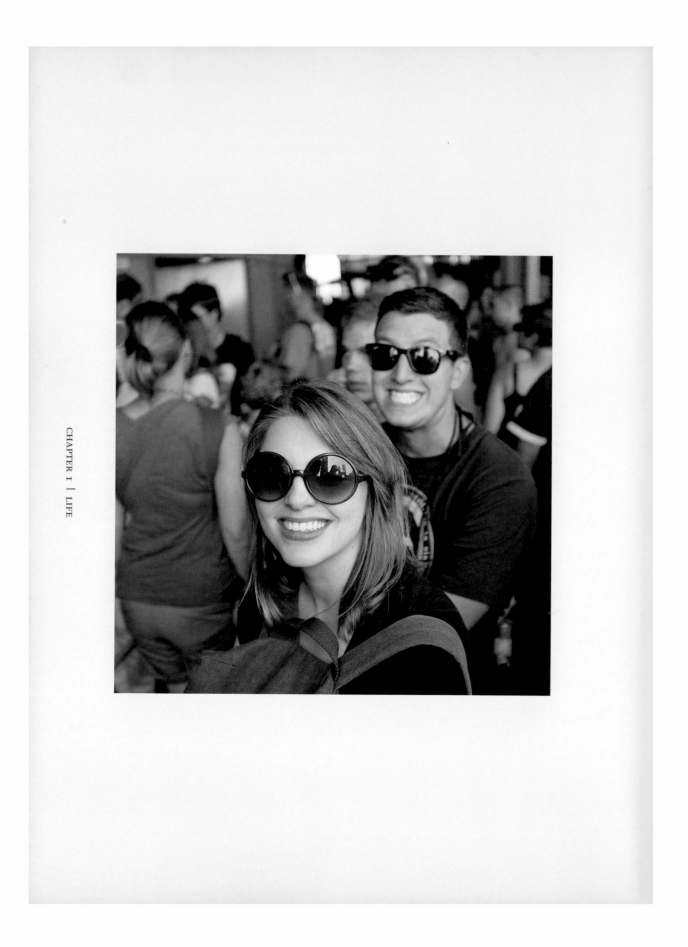

Legal highs

You don't always need grand gestures to make you feel better about life. I've worked out ways to appreciate the moment I am in, to help me focus on positive things rather than the things that weigh me down. These are my legal highs, my instant pick-me-ups:

1. Perfect cup of tea in the morning
2. Seeing my dog run around
3. Fresh flowers and plants
4. Waking up with the sun shining
5. Seeing a puppy
6. Afternoon nap after a big meal on a Sunday
7. A spotless kitchen
8. A fresh haircut
9. When you put your music on shuffle and love every song
10. Finishing a great book

The year I stopped laughing

Talking about mental health is important, but it's not always easy. I have never publicly spoken about my struggles with anxiety and depression because I was afraid of judgement or not being taken seriously. It's something that I always considered to be very personal, but I've learned that talking about these experiences can be very helpful to other people. If my story can make someone feel like they're not alone or that there is a light at the end of the tunnel, then I consider it my obligation to be open about it.

As you will gather from reading this book, I am a very anxious little creature. It's in my nature to be worried and I get worked up about small things very easily. I guess it's one of my endearing qualities (at least that's what other people tell me), but I think a lot of people don't know the extent to which anxiety has affected my life. To me, anxiety feels like that uneasiness you get in your stomach just as you're about to go around a loop on a rollercoaster, but sometimes it hits for what seems like no reason at all. I've had to cancel many events because I physically couldn't get myself there. It's a type of fear that paralyses you even though you know it's irrational.

I remember getting my first panic attack in the hallway of my high school and thinking I was going to die right then and there. Everyone experiences panic attacks differently, but I personally lose the ability to breathe and talk for what feels like an eternity. It is very frightening, especially when you have no idea why it's happening or when it's going to hit you. I told my mom about my panic attacks and she thought I was being dramatic. To be fair to her, I am very dramatic and, at times, a hypochondriac, but this was very real. I suffered in silence with my anxiety for a number of years and figured out ways to deal with it to make it a little easier.

Years later, my mom and I were driving down the street during one of my trips back to Canada. It was a totally ordinary day until my mom started breathing very heavily and had to pull over. As someone who has had anxiety attacks regularly for years, I somehow did not put the pieces together that my own mother was experiencing a panic attack for the first time. I spoke to her calmly and we both thought that maybe she just needed to go home and get some sleep, so we cancelled our plans and, once home, I took her up to her bedroom. She seemed so fragile and I had absolutely no idea what was wrong.

A few minutes later I went back to check on her and she looked terrified. Sobbing, she grabbed me as tight as she could. At this point I was scared as well and I didn't know what else to do but take her to the hospital. We got into the emergency room and as I was filling out the paperwork I glanced over to see how she was doing – and what I saw will haunt me for ever. Her neck was no longer supporting her head, her eyes had rolled back inside her head and she was beginning to convulse.

I dropped the clipboard and ran over to her screaming. 'She's having a stroke!' I shouted, 'Somebody help!' The nurses ignored me and no one around me was alarmed; it was the most surreal thing I have ever experienced. It felt like a nightmare. I noticed a doctor walking through the corridor, so I ran towards her and physically pulled her towards my mother. She wasn't responding to any questions, but after two to three minutes (it felt like years) my mom made eye contact with me. She was looking at me, but it was like she wasn't there at all.

Time stood still as I tried to make sense of it all. The doctor told me not to worry as we wheeled her into a private room; apparently it was *just* a panic attack. So that, ladies and gentlemen, is what a panic attack can be like.

My mom is still shocked that all of that happened to her, but now she understands anxiety and what it can entail. After that ordeal she told me that she couldn't believe that is what I had been dealing with for years, but I assured her that my anxiety never got to that level of scary. Even I didn't know that was possible. Thankfully my mom is okay now, and my own anxiety is much more under control and no longer dictates how I live my life.

**Learning to manage my anxiety took time, support
and finding the courage to try to overcome it. It also
took me reaching rock bottom after months
of struggling to cope with depression by myself.**

My move to England was a very confusing time because, while on paper I should have been happy, I was hurting so much mentally and emotionally. They say you should do one thing per day that scares you. Well, when I moved to England I was doing about 50 things a day that terrified me. It probably took me about two years to fully acclimatize to British culture after my initial move to Cambridge.

I was battling with what I considered the loss of my old life. I had a few part-time jobs, but I wasn't emotionally stable enough to take on much more than that. All of my work contracts were for very minimal hours; for instance, just working on Saturdays, usually for four-hour shifts at the most. I was very fragile and left work crying at least three times because my manager had raised his voice at me. It was such a contrast to my old job in Canada where I was super close with everyone I worked with.

Once Aslan walked me to work one Saturday and as soon as I saw the shop I burst into tears and refused to go inside. My anxiety was sky high and I just couldn't take another day. My hands were shaking, I felt dizzy, I was upset, and just generally felt sad and scared. Poor Aslan; I don't think he knew how difficult I was finding the transition until that morning. He hugged me and we walked back to our flat together where he made me a cup of tea and we watched some good old morning TV. I felt much better.

Sometimes I wouldn't leave the flat for two weeks because I was so scared to face the outdoors. Fear is a funny thing because sometimes you can feel afraid even when there's not necessarily anything to be scared of. The best way I can describe the fear that anxiety brings to someone who has not experienced it is this: you know the phrase 'I've got a bad feeling about this'? Well that's how I felt constantly. I wasn't sure what could go wrong, but I knew there was a chance something horrible could happen. What

if I went outside and someone got hit by a car? What would I do? What if my mobile phone didn't have reception and I couldn't call for help? What if I didn't know what street I was on and I couldn't give the ambulance driver directions? These types of fear-driven thoughts would go through my mind at every turn. Our flat was my safe haven; nothing bad could happen there: it was my base camp.

Anxiety doesn't always make sense and at the time, even though I had suffered from panic attacks before, I didn't know what I was experiencing was anxiety – that's what made it so much scarier. I felt broken.

One sunny day I woke up with a more positive outlook and I thought I'd seize the moment and try to cheer myself up by treating myself to a few new make-up items. I went online to research which British products might be good as I still hadn't had the pleasure of walking through the aisles of the British drugstore. I didn't make it to the shops that day because I was so enthralled by what I had discovered online: the big new world of beauty blogging. That was the beginning of my life changing for ever – the day I decided to start my own blog. But it didn't fix everything. It's not as simple as that, unfortunately.

Depression and anxiety go hand in hand, however, I never thought I would experience depression. I'm not sure why I thought I was immune to it, especially because it's something that every single woman in my family has dealt with. Looking back, I definitely had bouts of depression throughout my teenage years.

I'm calling the time depression hit me the hardest 'the year I stopped laughing', because I did in fact stop smiling and laughing for almost a year. I feel like depression kind of crept up on me.

I was very emotional, lethargic and nothing interested me. I felt worthless, useless, I was emotionally unavailable to everyone around me, nothing mattered to me; I was not in my body … I was a ghost of myself.

I remember one day I was in the bathroom and Aslan asked me, 'Are you okay in there?' and I broke down into tears. I promised Aslan I would make an appointment with the doctor, but I think I was so deeply in denial that anything was medically wrong with me that I never made the appointment. I had no idea what was wrong, but I felt guilty for feeling so down because I had everything I had dreamed of at that point in my life. I knew I was lucky to have the life I had, but for some reason none of that mattered.

About eight months into my low mood, something came over me. I was exhausted and tired of putting on a brave face every day. I couldn't do it alone any more. I felt very scared and looked all over the house for Aslan.

When I finally found him in the shower I ran into his arms, fully clothed as the water washed away my tears. I think Aslan knew that I had reached a rock bottom of sorts and he did exactly what I needed him to: he let me stand in the shower with him and cry. Once he convinced me to get out, he dried me off and put me into some dry clothes. Even I was shocked at myself – how could I have let my depression get to this point?

The next morning I made an emergency appointment with the doctor. We discussed how I was feeling and then he prescribed some medication that would help me. I felt humiliated and it took me a few days to pick up the prescription, but eventually I realized that depression is like any other illness. I didn't get embarrassed when I got a throat infection, so I should not be embarrassed about this.

Medication isn't always necessary, but it was the difference between night and day for me. All I knew was that I couldn't continue to wake up feeling like I did and I couldn't do it alone any more. I became hopeful, more positive and excited about things again.

If you are going through depression, just know that it's not for ever. I know it feels like you're going to be unfixable, but you're not. Everything is going to be OK – just talk to someone about it.

How to pick yourself up

Not everything is positive in this life (although Instagram would lead you to believe otherwise). Sometimes life gets you down and it's hard to get back up again. When it comes to tough times, it isn't always the easiest thing to open up to someone and tell them how you're feeling. That being said, I think it's the most helpful thing you can do. I'm the type of person who likes to mull over emotions a bit on my own before sharing them with others. When it came to my depression, I made the mistake of not talking to anyone about it for a very long time. As soon as I did mention it to Aslan it felt as if a weight had been lifted off my shoulders; I was not in this alone any more.

As well as deeper mental health issues, things like comparing yourself to others or feeling like nothing is going right are also valid emotions that can be helped if you discuss them with the people you're closest to. There's only so much moping around in a robe a person can do before they realize something has to be done about feeling so low!

Experience has taught me that it's always possible for things to get better. I've been very low and bounced back and I've done it a lot of times in my life. That experience is comforting when something sad happens to me today – just knowing that things will always get better. Even when you think there is no way out of a situation or that you'll never be happy again, trust me, you will be. You will be okay.

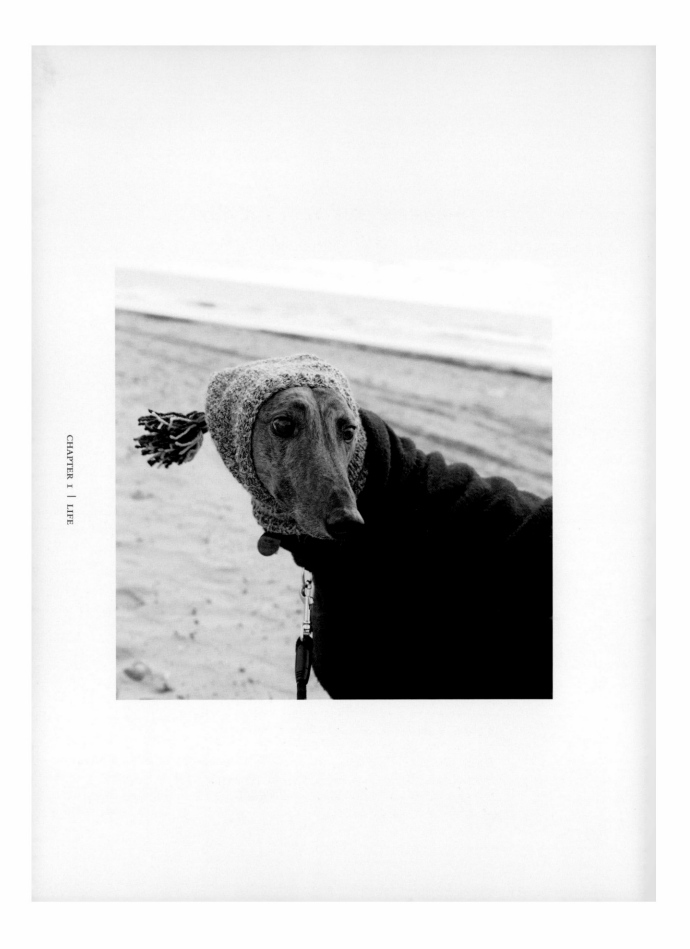

An ode to dogs, especially our greyhound Reggie

'Dogs are angels' is an actual thing I said the other day. I've had dogs around me for my entire life and I hope I continue to have dogs around me for ever. If you're a dog lover or owner, you already know that dogs are not just animals. Dogs are family and, for us, our dog Reggie is our son. He is the light of our lives and gives us so much joy.

Having a dog has given me a sense of purpose. Every morning I wake up, go downstairs and he is there to greet me with his beautiful brown eyes. What a way to start your day – bliss! After that, I take him outside for a walk in the crisp morning air. Without having a dog I would never get outside just to go for a walk. He gives me a reason to get some fresh air, listen to the birds chirping and take a few moments to clear my head. Aslan and I have met so many dog owners in the area as well and it's given me a sense of community, even in a big city like London!

I genuinely don't know what Aslan and I talked about before Reggie came into our lives because he is 99.9 per cent of our conversation topics. There is never a dull moment with a dog around. They are hilariously entertaining. Even the way Reggie's eyes bulge in concern if the doorbell rings cracks us up!

I've also done a lot of reading about how dogs have been proven to reduce stress, anxiety and depression. I know for myself that Reggie was a huge factor in helping me deal with a lot of personal issues and he helps lift my mood every single day. I don't feel lonely when I have Reggie beside me – it's like always having your best friend around. I talk to him about everything, even if it's just to let him know what I'm planning on having for dinner. My life wouldn't be the same without him.

Don't you find it amazing when your dog consoles you
if you're upset or sick? They seem to have an incredible
ability to read our emotions and thoughts, and sometimes
it feels like they are more capable of it than humans. They
are loyal to their owners and they can understand what
sort of body language you're using. I'm not ashamed
to admit that Reggie has got me through some pretty
emotional episodes of *Grey's Anatomy*.

Who rescued who?

There are so many animals in need of a caring home. I know
puppies are cute (they're my favourite things in the world)
but please, please, please consider adopting an adult dog
first. All animals deserve our love, not just the cute ones.

An adopted dog will love you just as much as a puppy
– you will not be missing out on anything by adopting.
Instead you will be providing an animal with a loving
home who might not have had one in the past and who
might have been put down otherwise. I know it sounds
dramatic but you are literally saving lives by adopting!
You will be showing an animal that not all humans will
abandon them, not all humans will mistreat them, and
you will show them that there is love in the world and
that they most certainly deserve it.

All good animal rescue centres will also make sure you
are suitable for the kind of animal you want to adopt, unlike
most breeders who do not do home checks or ask questions
about potential new owners' lifestyles. A good shelter will
make sure that both you and the animal are compatible
before you take them home. This gives you and your pet the
best chance to live happily ever after. So I beg you: please
consider adoption if you are thinking of introducing a furry
companion to your life. It really will be worth it, I promise!

Aslan and I had talked about getting a dog since the day we met, but we weren't in the proper circumstances to look after a dog until we decided to get Reggie. Because I work from home, a lot of the time alone, I can start to feel very lonely. That was one of the main reasons we decided to get a dog in the first place. After doing a lot of research, we knew we wanted to adopt a retired racing greyhound.

Most people assume that greyhounds need loads of exercise and space to run in, but it's quite the opposite. They will be happy with just two 20-minute walks a day (although we choose to walk him more), but if you occasionally want to take them for a two-hour walk in the woods then they will be more than happy to join in. They are amazingly flexible that way. One other thing that needs to be mentioned is that they love to sleep all the time. I thought it was an exaggeration, but having witnessed him sleeping all morning, afternoon and evening for a few years I can confirm that it's true. The babe is very, very chilled out and he brings such a calming energy to our house. He's a friend to everyone. In fact, most times when I walk him, we are likely to encounter a kid screaming 'Reggie!' as they run up to pet him. The way Reggie is so gentle and patient with kids absolutely kills me and brings me such happiness. If happiness was a physical object and covered in fur, it would be Reggie.

Because Reggie had a very strange existence of racing, living in kennels and not having much affection before he came to us, he is so appreciative of every little thing we do for him. When we pet him, you can see him smiling. When we give him a bone, he twirls around to say thanks. It's almost as if he can't believe he's lucky enough to be getting loved! It's both heartbreaking and fulfilling to see him this way because I wish it could have been like this for his entire life.

On the day we went to the rescue centre to find our dog, we had no idea what to expect. We were told that we would walk five dogs and see which one felt like the best fit. Reggie was the first dog we walked that afternoon and as the volunteer let him out of his kennel, I knew he was the one.

He bounded straight for Aslan and me as if he was finally coming home – I will never forget it. His tail was wagging like crazy, he was twirling around in excitement, and it really was love at first sight.

His transition wasn't necessarily the easiest thing in the world. At the ripe old age of six, Reggie had never been in a normal home before, he was only used to a kennel environment. Our wooden floors petrified him; it was like seeing a deer on ice. He was (and still is) terrified of the stairs and refuses to use them, so he lives on the ground floor. Sirens made him shake with fear, other dogs made him very uneasy (as he'd only ever been around other greyhounds) and he didn't know how to play with toys. We had prepared for him by buying lots of different types of toys but when we tried to play with him he was like, 'WTF are you guys doing? And what is that you're waving in front of me?!'

But being the little trooper that he is, he has been able to overcome the vast majority of his fears and anxieties; it just took a little time. Through love, patience and kindness, Reggie has blossomed into a much more confident dog. He loves toys now! It has been so rewarding seeing him become comfortable in his skin and how his trust of Aslan and me has grown so much. He knows we adore him and he adores us right back. We didn't rescue him, he rescued us.

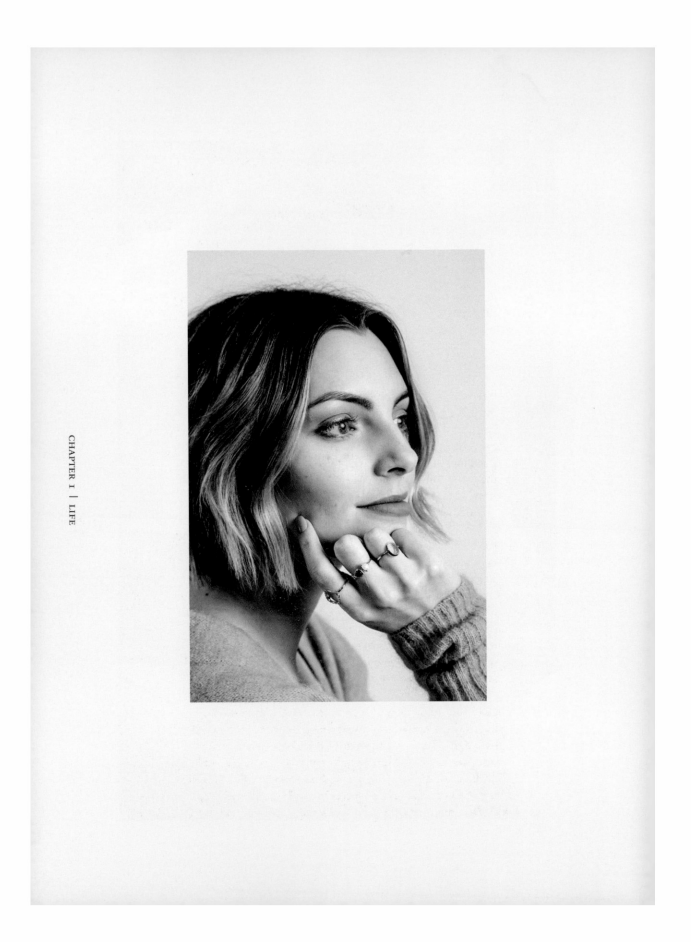

CHAPTER 1 | LIFE

Finding you

The following is an extract from an article I wrote for *Darling* magazine back in 2015, about working out who you are and being kinder to yourself.

'Stop living in your head so much,' my mom told me on my 25th birthday. How could I stop living in my head when I've always been someone who overthinks things, replays events in my mind over and over again, and won't rest until I've thought of every possible outcome? I suppose it's not the worst thing in the world, but over time this relentless stream of consciousness can become draining.

Growing up and understanding the person you are is difficult at best and completely incomprehensible at worst. No doubt my decision to do a lot of that growing up on other people's computer screens has made the process that little bit more complex for me.

For a long time I considered succumbing to fears telling me to stay inside my comfort zone and opt for a more conventional career, but *Mean Girls* taught me that the sky is not the limit because the limit does not exist. I did a lot of reflecting before making the decision to push myself, and I'm so very glad I did.

Looking back, I wish 17-year-old me knew to let go of the minor things, to embrace myself without hypercriticism: when I was a teenager, sometimes I would look at my outfit in the mirror for an hour just to make sure I looked OK. I would redo my make-up, fiddle with my hair, suck in my stomach and feel emotionally deflated. Usually I felt like I didn't look OK, so I would change my clothes, repeat the process, and sometimes get so flustered

I would cancel my plans and get back into comfortable loungewear. Thinking back on this now makes me so sad because I didn't even give myself a chance to feel good.

Why are we so hard on ourselves? When I looked into the mirror I would think, 'How bad do I look right now?' rather than, 'I look great today!' and have a quick teeth-check and move on.

The 17-year-old me was wise in some ways. She let me reinvent myself as many times as I needed, for example. As an attempt to find ways to feel happy in my own skin, I experimented a lot with new clothing styles and tried out different social groups to explore certain parts of my personality in a more magnified way.

Each time I went through one of these transformations I learned something new about myself, and so I now look back at all of these phases fondly. I always thought meeting new people was terrifying, but all of these past interests and hobbies of mine are coming back to me and make for some great conversation starters!

And even though my experiences have meant I am able to give you a more coherent answer to the question 'Who am I?' at 25 than I would have been able to at 17, I still have a long way to go and it's a quest I am obsessed with.

WHAT I WOULD SAY TO MY 17-YEAR-OLD SELF NOW

It's OK to be vulnerable in front of others (just make sure they are the right people). Sometimes it's totally necessary for your sanity! I am a little crazy and take this to the extreme: I really lay it out there for everyone to see online. I think it's important to realize that's a different kind of vulnerability, albeit a more polished one. The kind that we all need is the raw kind, the kind you share with the friend or relative who really knows you and won't judge you.

I'll be the first to admit that I'm still as confused and lost in this world as I have ever been. But being lost at 25 is so different than being lost at age 17. So although sometimes I still look in the mirror and don't like my outfit

or feel completely at a loss about the trajectory of my career and my purpose in this world, at least I'm on the journey to looking into my own eyes and feeling secure about who I'm becoming. I've got plenty of space to try new things, transform and grow up with my audience, and it's comforting knowing that we're all in the same boat but getting off at different destinations.

THINGS I KNOW ABOUT MYSELF BECAUSE I STEPPED OUT OF MY COMFORT ZONE

1. I don't like camping as much as I wish I did
2. I love drawing even though I'm terrible at it
3. I'm passionate about empowering other people to do their best
4. One of the most important things about me is that I need alone time to be my best self
5. I'm a bit of a control freak, but it's okay to give up some control

Dancing otter on
sparkling water

Sometimes the most wonderful things happen when you get the opportunity step out of your comfort zone. I was 16 and still living in Canada. My aunt worked at a women's prison and one day she was explaining the purification ceremony, also known as the sweat lodge, that the Aboriginal Canadian inmates conducted. It sounded fascinating and I asked if I might be allowed to attend the next one to see what happened.

In the outdoor area of the prison there were about 30 women preparing for the ritual. They had built a tent and we were all squashed together in a circle around the fire at the centre. There were large hot rocks on the fire, which were splashed with water to create steam. The ceremonial leader, the elder, began chanting and banging on a drum. With the heat from our bodies and the steam coming from the hot rocks it was stifling and so steamy I could barely see my own hand in front of my face.

A jar of bear oil – made from bear fat – was sent around the circle that we were supposed to rub on the areas of our body that needed healing. 'If you're heartbroken, rub some oil on your heart,' the elder said. 'If you're confused about your path in life, rub it on your temples.' Needless to say, I slathered the oil over every centimetre of my body.

Then, suddenly, the drumming and chanting stopped and the elder said that there was one person in the tent who had not received their earth name … She poured more water on to the stones, the steam filled the tent, and then she pointed at me and bellowed, 'Dancing Otter on Sparkling Water.' I loved it.

We all left the tent to have some food and regain our strength. The elder later told me that my new name meant that happiness would follow me for ever, and that I have a spirit that always tries to make the best out of things. I felt cleansed and exhilarated. It was a one-of-a-kind experience that I will never, ever forget. My aunt drove me home and, just as we pulled into the driveway, my mom was heading out to walk the dog. She took one look at me and my frazzled hair and sweaty body and, after she stopped laughing, she yelled, 'Rock on, baby!' When you get a chance to try something new, take it.

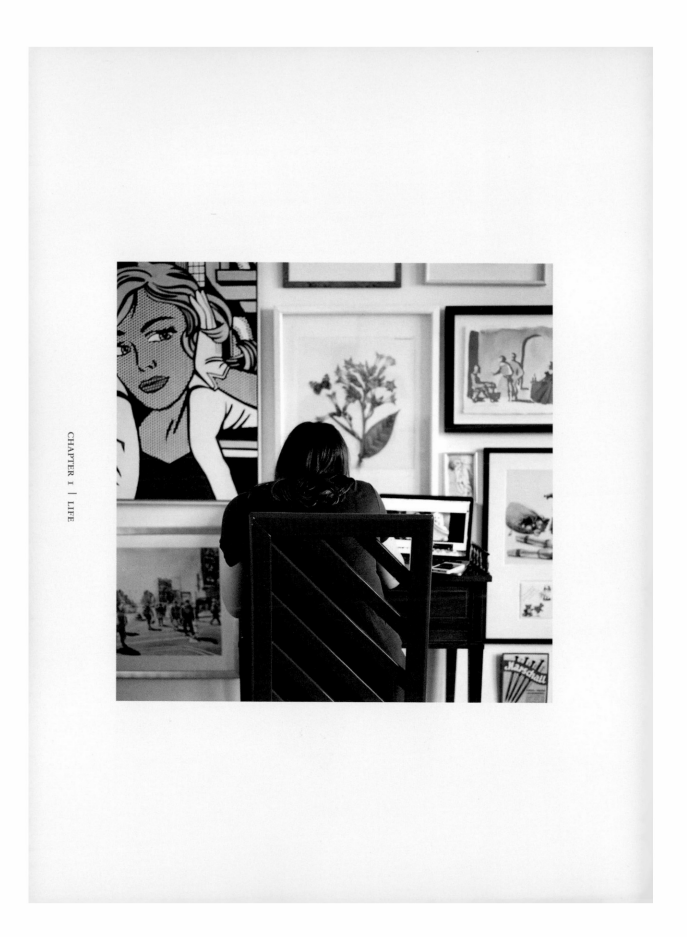

Me time

I was a happy kid. My mom said I was born laughing and I could always find the funny side of things. I was very imaginative and have always considered myself to be a proud loner.

While I can be a social person, I am most definitely an introvert, so I find certain social situations a bit difficult. I need to have a proportion of my day either being alone or able to be silent and just be with myself. I'm not the type of person who chats through a flight. I'm not the type of person who likes to talk during cab rides or spend hours on the phone. Some people understand that (probably because they feel the same) and some people think I'm uninterested in them, but I really just need time to recharge my batteries!

Luckily, Aslan and I have mastered the 'awkward silence' – now known to us as the 'not-so-awkward silence' – and we can spend hours beside each other not saying a single word. If I can be silent around you for extended periods of time, chances are we going to be besties for life.

My alone time can be as simple as scrolling through social media and reading my emails, petting Reggie, watching TV, closing my eyes for 15 minutes ('I'm not napping, I was just closing my eyes!'), taking a bath, tidying the kitchen, etc. Me time isn't anything special, but whatever I'm doing … I'm alone.

Two
—
People

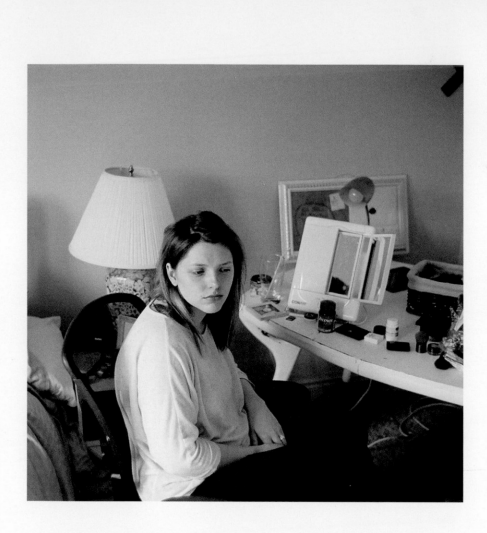

When I moved to England I found it to be
so much harder than anything could have
prepared me for, and I didn't really
understand why it was so hard for me
until I started writing this book.

From a very young age, right up until I was 18 years old, I never felt quite settled in any circumstances except when I was at home with my family. I often hear people say that they're from a 'tight-knit family', but my brother and my mom were (and still are) the glue that held me together. I've always had an 'us against the world' attitude with my mom and brother, and that's a bond that doesn't break. I suppose we all have to grow up eventually, but to me this wasn't an issue with growing up. I really felt like a piece of myself was taken away when I moved to England.

Part of life is about setting your own goals and working hard to achieve them. I feel like I'm never going to be finished because as soon as I reach one goal I've set myself I am on to the next one. To keep this type of energy and motivation going we all need a support network to re-energize that passion every now and then. For me, it's my mom, brother, Aslan and my grandma (although my grandma always tells me to, 'slowwwww dowwwwnnnn').

Life support

To this point, there are two women I respect most whose words have shaped me from the inside out: my grandma and my mom. My grandma always tells me to 'stay nice'. Sometimes it's hard to be nice, especially when I have felt used, judged or unappreciated by others, but being nice always feels good. And no matter the reason I call my mother, her advice is always the same: to 'follow your heart'. It may seem simple, but when I do these two things I feel like I'm my most pure self.

Following my mother's advice has been a journey of pushing outward from what I know already to find those things, people or experiences that resonate most with me. I've learned that sometimes this will work out great and at other times I might feel stupid, terrible, embarrassed or a combination of all these things. But that doesn't matter in the long term; what really matters is that I keep on pushing those boundaries, because the further I push the more pieces of my internal puzzle I find.

I have found that one of the scariest but most effective ways of doing that pushing is by being honest with myself. I think on reflection that it's OK to admit to yourself that you don't have it all figured out, or that it's going to take some time to feel whole. It's surprisingly easy to trick ourselves into thinking we're being honest about our thoughts and emotions. Nothing worthwhile changes overnight and as someone obsessed with instant gratification that can be a hard thing to realize, but I'm getting there. Also, admitting to myself that I need help from others and then leaning on loved ones for support is a great tool that I wish I had found earlier in life.

From Mom

Dear Estée,

I never wanted to get married or have children. I was a free spirit and didn't want to be held down or be accountable to anyone. Little did I know that having children is actually my elixir for a fulfilling life.

It's funny what things you pass on to your children without even realizing it, both good and bad. My dislike for Christmas and cooking sadly have been passed along. My love for travel and animals is now both of your joy. In return, among many other things, you and your brother have taught me that anything is possible with the right attitude and that, yes, if I put my mind to it, I can learn how to Snapchat.

I marched to my own drum beat and now both you and your brother do the same. You with your own vision in different types of media and lifestyle, and your take on life; and Eric with his amazing talent in music and humour, and his ability to fix almost anything. You both started out as best friends and remain that to this day.

I have to stop myself from wishing that you were little again. Reminiscing about you and your brother living in your bathing suits and running through the sprinkler all summer long, baking cookies just so we could lick the beaters, camping for four days in torrential rain and throwing out the tent out on the way home.

I was never the person who said 'I love you' out loud, though it was always expressed through my actions and affection. But today, I do want to say it. I love you Estée and Eric. I'm so incredibly proud of you both and you have made this world a better place.

Love, Mom

Oh, brother!

My brother is my favourite person in the entire world.
He is the only person who can make me laugh so hard
I actually just start screaming (it's really weird). My mom
loves telling the story about how she caught me whacking
my newborn baby brother on his face with my toothbrush
whenever she wasn't looking. I guess I was a little jealous
I wasn't the centre of attention (I am a true Leo), but
luckily we grew up to be the best of friends.

 Besides hanging out together all of the time, Eric and
I truly understand each other because we went through
everything by each other's side (good and bad). We were
there for each other's awkward phases, saw all of the
highs and lows, and we'll always be there for each other.
Although we live very far apart now, we still manage to
go right back to how things used to be when we see each
other in person. He was always the person I could lean
on when I needed it and I hope I provided him with the
same comfort. We spent so many summer nights chatting
about what the future would hold and we always try
to encourage each other.

 Eric – who I nicknamed Maury because we always
used to fake illnesses so we could stay home from school
and watch *The Maury Povich Show* – is so smart when
it comes to figuring out how things work, something
I unfortunately cannot grasp. He is a self-taught guitar
player (I get to sing our made-up songs) and he can fix
absolutely anything (we are polar opposites in that regard).
He knows everything about cars, which is why he was
so horrified when he found out that I once drove my car
on a flat tyre for 45 minutes without realizing it.

We can both be a little awkward, so we love exchanging stories on how we've been weird and how we don't give a care about what other people think. If there's anyone who doesn't give a shit about the haters, it's Eric, and he always has a unique way of looking at even the worst situations. He's like a little turtle going through life, enjoying the good times and shrugging off the bad. I wish I could be more like that. I can be quite tightly wound at times and talking to Eric always makes me realize that most of what I worry about do not matter in the grand scheme of things.

God, we had some great times growing up, a lot of which I can't share in this book due to their mischievous nature – plus I don't want my mom to know what we were really up to when we got home at 3am. I am actually laughing as I type this because he made all of those awful teenage years bearable.

Eric took me to his friends' parties (when I wasn't invited to any parties myself), we share a love for *Mrs. Doubtfire* and I loved hanging out in his man cave (my mom's basement, which he converted to his bedroom) while he collected up the empty beer bottles from the night before.

He is a nice guy. Like, a genuinely nice guy with a conscience! He will kill me for saying this, but he is so sensitive. He likes things to be just right and he can be very intuitive if he's in the right mood. Don't get me wrong … we fight. They say siblings are the worst enemy you can't live without and that's definitely been the case with us. We really know how to piss each other off, but since we don't see each other that often we try not to push those buttons.

I couldn't have asked for a better brother and Eric is more than just a brother to me. He is one of my best friends, my personal comedian and the person who has no issue bringing me back down to earth if I'm getting too focused on the wrong things. I really don't know where I would be without him. I've spent my whole life feeling like I've been the big sister protecting him, but he was the person protecting me and shielding me from hurt. I can't believe we're grown-ups now!

I love you, Maury – follow your dreams!

Rebuilding bridges

I remember reading somewhere once that four out of ten marriages in Canada end in divorce. It seemed to me that divorce was quite common and that it was not something out of the ordinary that I lived in a divorced family. My mom and dad separated when I was just two years old and because I grew up with that situation it honestly seemed quite normal to me. I certainly never gave too much thought or weight to the idea that growing up with divorced parents really changed or shaped me; to me, it was just the way things were.

I've always been the person shouting from the rooftops that it was totally fine and it didn't affect me at all! I have no recollection of my parents being together and whenever I see a photo of them as a couple it makes me feel very confused. I just cannot imagine them in a relationship. I had a wonderful childhood and in a way I got to experience a lot more than a kid with married parents. For example, I got two Christmases and two birthday parties, and that never felt weird to me because it was the way it always had been.

Hindsight is a funny thing, though, and having put a lot of thought into this recently I am now starting to realize just how much it did impact me. I saw my dad every other weekend and after school some days. He lived in the country so we got to do a lot of outdoors stuff like ride snowmobiles and tractors, and chop down trees in the forest. But how much can a parent really understand their child when they only see you six days out of the month at most? It wasn't so much of an issue when I was a young kid, but as I got older and started carving out my own path in the world my relationship with my dad definitely suffered.

I remember being a typical teenager and feeling annoyed when my dad didn't know what my friends' names were or what my favourite band was. We just didn't 'get' each other and our shared genetics meant that our stubborn personalities clashed. Obviously, when you're a teenager it's hard to empathize with other people, especially your parents, and I know now for a fact it was heartbreaking for him as well.

When I was around 14 our relationship started to become strained due to our personalities clashing more and more. There are a lot of layers to relationships and there were events that I'd rather not revisit in this book because I want to look forward. As time went on, I just couldn't see eye to eye with him on most issues and our arguments meant that, from my perspective at the time, it was easier for me to have less of him in my life. Sadly, this meant that we lost touch and became estranged for many years, only speaking every now and then on the phone. When I moved to England it created an even bigger wedge between us. I've spent a long time feeling angry and sad that I didn't get to have the kind of relationship I felt like I should have had with my father.

My relationship with my dad is something I have never mentioned to my viewers because it's personal and still feels quite raw. Neither of us made it easy on each other. Thankfully, time has a way of unwinding knots. Something changed in both of us and I think we'll be able to go forward as two adults almost starting from scratch because we are both starting to understand that a functioning relationship is worth it. I taught him how to use WhatsApp, which he now uses to text me photos of the maple syrup he's made (how Canadian, eh!), and I send him photos of Big Ben.

It's kind of weird, to be honest, but it's nice. I no longer hold anger in my heart and I feel so at ease knowing that things are on the right track.

I almost didn't want to write about this, but I hope that if someone is going through a similar situation they might be inspired to pick up the phone and call that person they've disconnected from. When you're ready to put the past behind you, do it.

And don't wait too long. It takes a lot of work to rebuild a relationship and it's not always comfortable, but I think it's worth it. Let's put the egos aside for a minute and try to see things from someone else's perspective … you might get some clarity. As *Frozen* taught us, sometimes it's best to let it go.

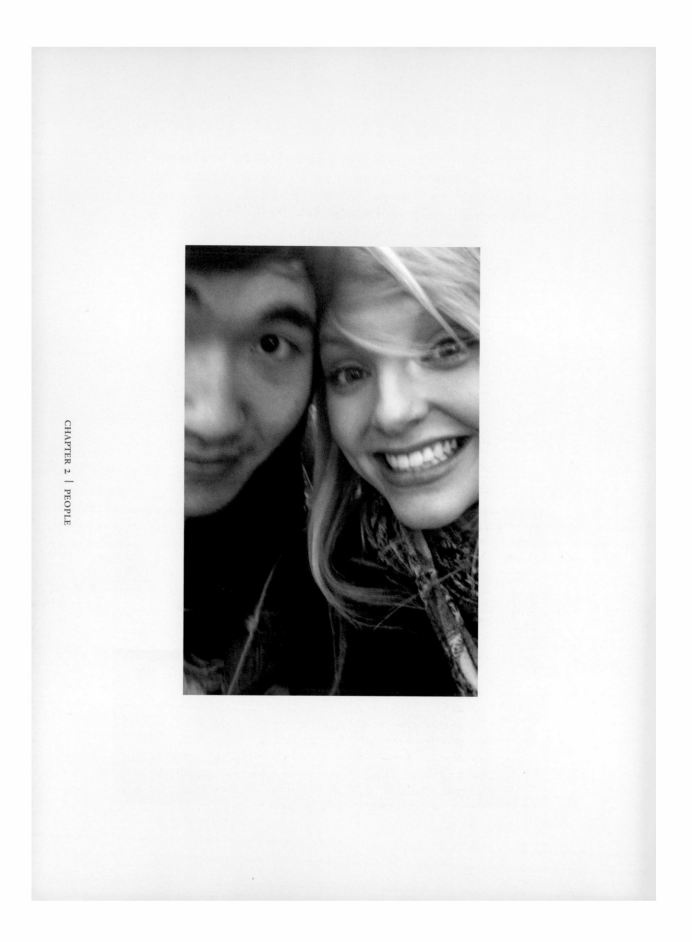

Following my heart

On 19 September 2009, I went online to kill some time on Tumblr. (FYI, I was an early adopter of Tumblr having opened an account just a few months after it launched two years prior.) I ended up clicking through to a text-based chat room that allowed you to speak to strangers and I started chatting to a man based in London. (Please keep in mind that in 2009 these chat rooms were actually quite tame and not too much cybersex happened. Okay?) That stranger was Aslan, my now boyfriend and the man I moved across the world to be with.

I knew that Aslan and I would be together for ever even before I saw him in the flesh. After our first momentous chat room conversation, we spoke via email and Skype for about ten months before meeting in real life, and during that time I felt a very intense and consuming love growing between us, one that I had never felt before. We had similar interests and personality traits, and he had a way of making me excited about life. He would make me little videos of his everyday life in London and I would show him videos of snowy Canada. We were total opposites, but for whatever reason that's what made it so exciting. I kept this online romance a secret for a long time because, honestly, it was embarrassing to meet someone online back then.

Eventually my mom figured out something was up and asked me who I was always talking to in my room and the jig was up! I told her that I had been speaking to a guy from England that I met in a chat room and that I thought it was getting serious – saying it out loud for the first time made it real. She sort of looked at me like 'okay … whatever …' and told me to be safe. If my memory serves me correctly, I think my mom actually Skyped with Aslan around seven months into our Internet romance – it was so awkward for everyone!

During those ten months, we talked a lot about how
we could meet each other in real life. I remember him
calling me on the phone one day when I was doing some
homework and he asked me what I thought about going
on a road trip with him across America. At first it was
the sort of thing we talked about but didn't think we'd
actually do, but as the summer approached I think both
of us thought 'what the hell!' and our lust for each other
overrode the nervousness. We both saved up our money
and my job was to buy a cheap used car for the trip
(shout-out to the Toyota Tercel). Just to recap, Aslan
and I had never met in real life before and this holiday
would technically be our first date. That's right, our
first date would last two months.

**Aslan flew to Toronto and, after I got over my majorly
cold feet that caused me to hide behind a pillar in the
airport, we had a top-notch make-out session. It was
so weird seeing Aslan in real life – he was so tall!**

After coming back down to earth, we ran to the car and
started our adventure – only to realize that I los the keys
somewhere in the airport. We found the keys at the lost
and found, and this time we were really on our way!

We were 19, drunk in love and without a care in the
world. We spent the night at a hotel in Toronto (heh heh)
and the next morning we drove back to my mom's house
(about one hour away) so that they could meet in person
before we hit the road. As we pulled into the driveway
I started to get extremely nervous about what my mom
would say. She was in the backyard on the phone when
Aslan and I walked over, but I could see in my mom's
eyes that she approved. She told me afterwards that she
could just tell he was a good person.

We spent the night at my mom's getting everything
ready for the trip and packing up the car. First stop was
Montreal where we got an extremely detailed hand-drawn
map of the city; next we saw whales in Bar Harbour; then

Aslan got hit on by every single gay man in Provincetown due to his rather tight and trendy bright red shorts; we did laundry at the world's hottest Laundromat in New York (during a heat wave); visited our first big casino in Atlantic City; ate only peaches and pecans in Savannah, Georgia; got our fortunes told in New Orleans; fell in love with the Magnolia Café in Austin, Texas; and drove up the Midwest through to Chicago where we ate a lot of deep dish pizza.

If there has ever been a time in my life I wish I could repeat, it would be those two months. I have never been that happy in my entire life and I was doing so many new things.

At the end of August Aslan flew back home to England. After bawling my eyes out in the airport (wouldn't be the last time I did that) I made my way through the crowds back to our car. The Toyota Tercel was sat alone and empty on the roof of the airport parking lot and summer was officially over. I burst into tears again at the sight of it. I dragged myself to the edge of the roof and screamed, 'NOOOO!' At that moment I was the most dramatic human being in the universe and I felt like I would never recover. Two weeks later, I had a one-way ticket in my hands (thanks to my mom and grandparents) and I was boarding a flight to England; I was following my heart.

Home is where the heart is

I had been in England for about four months (crying almost every day) and Christmas was coming up, so I decided to go home to Canada to spend the holidays with my family.

I spent about three weeks at my old house, reminiscing about my old life, and I spent a lot of time re-evaluating my living situation. For about five days before my flight was due to go back to London I would cry almost every time I looked at my mom. I had never seen my mother so emotional and I felt so empty, but so loved all at the same time.

Standing in the Toronto airport about to go through security was tough. My family isn't very affectionate, but when my mom hugged me under those blinding airport lights neither of us could let go. I have never felt so torn in all of my life before or since then.

That moment was a real fork in the road situation and I remember in that moment thinking I could always just stay in Canada and eventually I would meet someone else I loved (pfft). Somehow I got my strength back and eventually I ripped myself away and then cried all the way through security. I had a pat down as tears were streaming down my cheeks; I could hardly breathe.

I couldn't sleep on the plane that night and I remember telling myself to stay positive and see how things go. Millions of thoughts were buzzing through my brain, but mostly I remember feeling the pressure of the choice I felt I had to make: my family or Aslan.

'When you arrive in London, just see if you feel anything when you see him. Maybe this isn't the real thing and maybe this is just a fling like everyone keeps telling you,' I thought to myself. But when I wheeled my suitcase through the arrivals and saw only Aslan's face among a sea of unknown people, I knew it was real and I knew this was exactly where I was meant to be.

WHAT I'VE LEARNED ABOUT LOVE

1. Love conquers all … if you let it
2. True love knows when to give the other person space and when to get in their space to support them
3. When you know, you know. That annoying phrase is true
4. Compromising is an essential part of being in love
5. It's not all about you (I'm still working on this one)

Before we met in person, Aslan and I would send a postcard to each other every day.

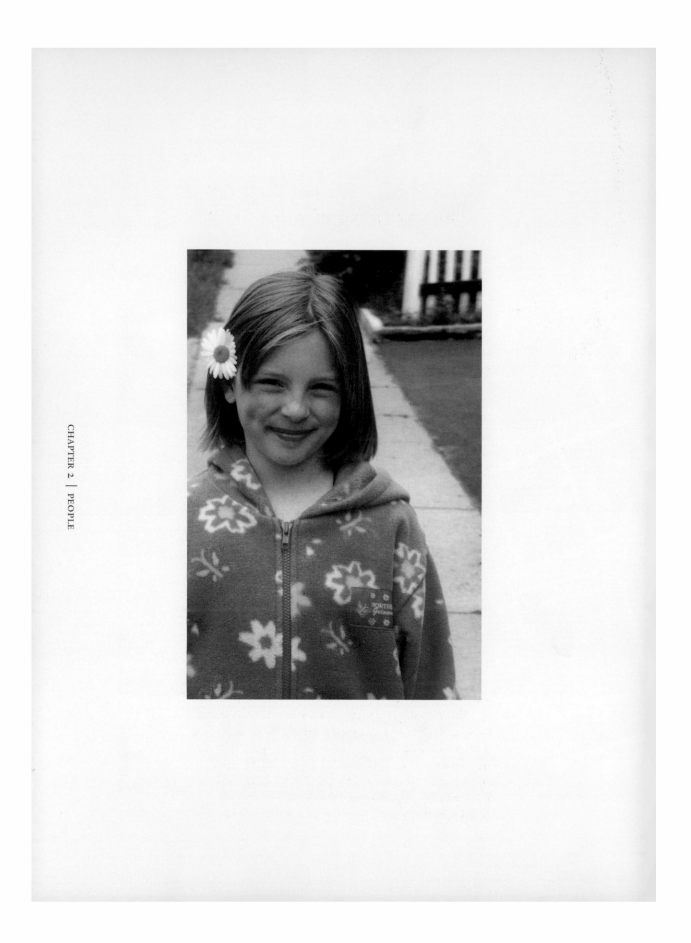

The meaning of friendship

Making friends has never come naturally to me, although I would say I can usually get along with most people. I've always found it more valuable to have fewer friends because I don't enjoy having relationships with people that are very 'tip of the iceberg' with conversations like, 'Can you believe this weather?' If I'm friends with someone then I want to trust them wholeheartedly and I want them to feel the same about me. I have a bit of a reputation for being able to get other people to open up to me and it's not unusual for me to see someone get emotional the first time we meet (I think I have this power from years of watching *Oprah*). In my experience, there is nothing worse than having a 'friend' who you feel uncomfortable around or, worse, someone you can't trust.

I can vividly remember being eight years old and solely concerned with making friends. When the twins at my school started a members only club called The Warm Fuzzy Club I would have done just about anything to be part of it. The twins were always the centre of attention in my class and they did everything together. They had all the best clothes, the best lunches, the longest hair, the biggest house with the best pool and the most friends. They used to go to a fancy summer camp for the entire summer and the stories they came back with were absolutely epic. They had it all.

You became a member of The Warm Fuzzy Club by going to a specific store called Northern Getaway to buy the 'members only jacket', which was a pink fleece coat with flowers on it. I asked my mom if I could try it on and stared at my chubby little body in the skinny mirror. I needed this jacket if I wanted to keep any sort of social status at school, but my mom said it was way

too expensive and she wasn't buying it. I unzipped
it reluctantly and put it back on the hanger.

I spoke to my best friend at school about joining
The Warm Fuzzy Club and we both agreed it was pointless
and we didn't need to join. We had been friends since the
first day of kindergarten and I thought we would be friends
for ever. The very next day at school she rocked up with
the jacket on. I was so crushed.

A few weeks later my mom surprised me with the
warm fuzzy jacket. I put it on and rode my bike to
school. The Warm Fuzzy Club glared at me – since I had
technically done the only thing necessary to join the club,
they reluctantly let me into their circle. I was quickly
reminded that I wasn't friends with these people. To make
it worse, the warm fuzzy jacket was uncomfortable as hell!
I should have given them all the finger and moved on with
life, but I was eight years old.

It was a gorgeous sunny spring day when the home-
time bell rang at 3:10pm. The Warm Fuzzy Club ran out
of the classroom screeching and screaming and waving
their arms up in the air. I was always excited for school to
end, but I had no idea why today was any different. Being
a slightly overweight eight-year-old made me the last to see
what they were all running towards … a limousine. WOW.
I couldn't believe there was a limo in our school parking
lot (I later found out it was the twins' birthday party). The
Warm Fuzzy Club poured inside. I was the last to reach the
car door and just in time to see my own reflection in the
shiny tinted window as the (evil) twins slammed the door,
rolled down the window and said, 'Sorry! There's no room
for you, Estée!' What a bunch of little bitches.

**At the time, my mom told me this kind of thing would
make me stronger, but I couldn't understand how I could
get strength from something that was so mean. This
was just the first of many occasions that made me feel
like I was never going to find my place in the world.**

I think this photo says it all.

The summer of that year I joined The Pink Panthers, a soccer team of girls from my city whom I had never met before joining the team. Everyone else's parents were driving minivans and dressing appropriately like Soccer Moms (old lady cardigans and corduroy trousers), but my mom wore high-waisted shorts, a leather jacket and heels, and drove a white Honda hatchback with cowhide seat covers. My mom never cared about what other people thought of her. She never let anyone make her feel like she didn't belong somewhere and she was always proud to be different. Thanks for being a badass, Mom!

As the warm wind blew my shiny blonde hair around the car I asked my mother if I could wear one of her lipsticks. It was a dark plum colour and it was the first time I had ever worn make-up. I felt so grown-up and I can still remember the taste of it on my lips. I excitedly ran out of the car to meet my new teammates. They ignored me. So I made it my mission to play like I'd never played before! Unfortunately, I managed to score a goal in my own team's net … twice. After we lost the game (I'm putting my hand up and admitting it was completely my fault), I cried all the way home. In an effort to console me, my mom spoke from her heart, 'You're meant to be something special, Estée!' And I never stopped believing that.

My position as an outcast taught me the value of real friendships and the importance of being nice to people.

Friendships continued to be a struggle for me when I got a bit older and started getting into the emo scene. I had a big streak of blonde in my fringe; a stark contrast to the rest of my hair, which I had dyed black. One night a few of my friends and I were off to a My Chemical Romance concert, which was a VERY BIG DEAL. Unfortunately, I was ridiculed the entire car ride home because I didn't know as many lyrics as my superfan friends. These weren't the friends for me.

CHAPTER 2 | PEOPLE

Social anxiety

After the social knock-backs, I shut myself down a bit and didn't allow others to become close to me. I had friends, but I never let them truly get to know me, and this has proved to be a difficult habit for me to break. Also, I used to feel so much anxiety when meeting new people, which is actually very common. Almost everyone I meet today says that they used to get nervous meeting new people and a lot of my friends in their late twenties still feel the same! Although this doesn't cure it, I take comfort in knowing that a lot of people struggle with this too and it's not just me freaking out inside my head.

I always assumed that I was going to come across as weird or uninteresting when I met new people and because of that sometimes I would be completely silent. Once I somehow got invited to hang out in this really hot guy's mom's basement (seemed a lot cooler at the time, okay?) and I don't think I said a single word. I remember going home and thinking, 'WTF is wrong with me? No wonder I don't get invited to cool parties!' Now when I tell people this story my friends say 'we've all been there'. It seems abnormal, but it is completely normal to be socially awkward sometimes.

Fortunately, now I look forward to meeting new people. When I started my blog I began attending events, meeting people in real life whose blogs I read and I began forcing myself out of my comfort zone. Since opening myself up (which wasn't an easy transition) I have met some incredible people from all walks of life, which is an immeasurably fulfilling experience. Through making videos in the comfort of my own space I have realized that there are a lot of people out there who do connect with me and like what I have to say. I'm so thankful I am now in a place in my life where I feel able to be myself in front of others – I just wish it hadn't taken so long!

1. Go into social settings thinking 'just be yourself'
2. Don't put on any fronts or personas to impress the people around you
3. The real party doesn't get going till you're much older. If you're still in your teens, you're not missing out now
4. It's OK not to get along with everyone
5. Focus on what you care about most and the real friends will come
6. If I'm feeling really wound up I will go to the washroom, look at myself in the mirror and say, 'You can do this!' That's just the mantra that works for me, but I suggest coming up with your own!
7. When I get anxious I find myself holding my breath. Take a few minutes alone to breathe in and out deeply and slowly – that always calms my nerves
8. Find someone you feel comfortable around and focus on them until you're relaxed enough to mingle with new people
9. Before a social situation listen to something such as music or a podcast. These types of distractions are very helpful to me
10. Remember that you're not the only person who feels anxious. It's just the feeling of adrenaline rushing through your body and everything will be okay

I wish my younger self knew that there were people out there in the world who would accept me – and not only accept me, but *like* me! What a concept.

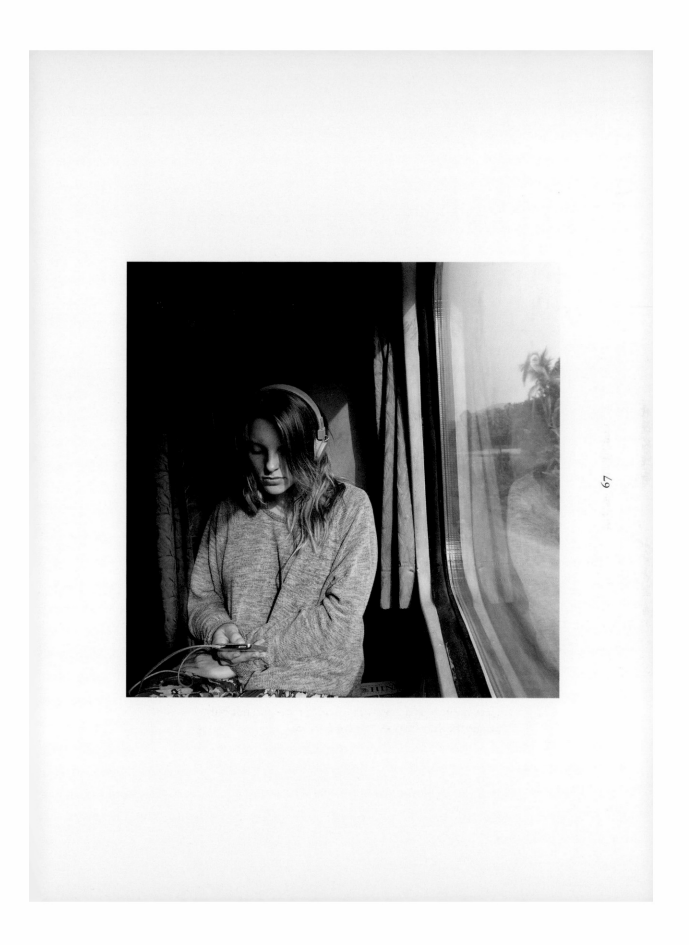

The true meaning of friendship

I made friends with two girls I worked with when I was around 16. These girls were in their last year of high school (making them 18) and I thought they were fascinating. We had a completely different type of friendship because they had a very 'been there, done that' attitude towards a lot of the awkward times a teenager goes through. We talked more about music and life beyond our small town, and I discovered that they were friends with people I had never even heard of! So I guess I didn't know everyone in my small town. Being friends with these girls really hit home the idea that high school years are a very short time in a person's life, so if they're crap don't worry. They were the first truly badass girls I admired because they did whatever they wanted and made no apologies for being different than the other people in their grade. We were a little trio for a while and I have never felt so cool.

Once my badass friends left to start their lives in the real world, I started getting close to someone else in my school who was loved by everyone. She was on the wrestling team, had a huge family and was always smiling. Her family lived on a farm and we used to have the best time wandering around the barn, exploring the forest with her younger siblings and just generally goofing around. I felt so free to be who I was around her and we found each other hilarious. We were friends for many years and we still talk occasionally today! Although we had very different views on the world we never judged each other and encouraged one another to go down our own paths in life. That's what good friendship is to me: acceptance, support and the idea that not everyone has to see things exactly as you do.

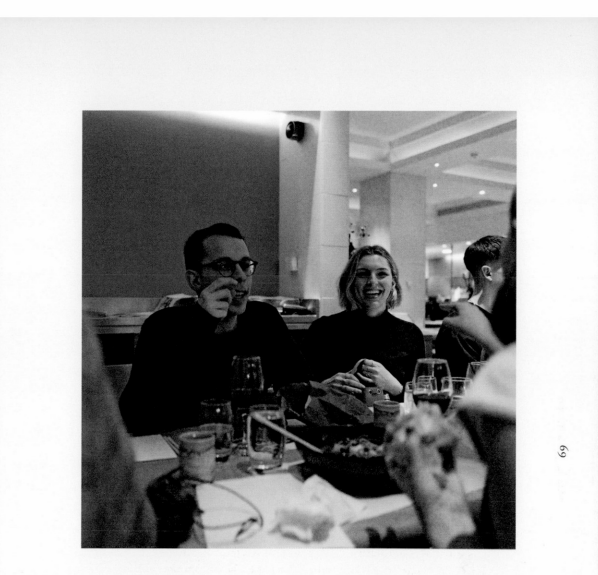

Friendships for me today, in my twenties, are quite
different than the ones I had at school. I still find
it difficult to truly connect with people and, honestly,
I'm at a stage in my life where I don't force it. If we
don't gel, I don't want to put on a fake façade and
go for dinner to talk about absolutely nothing.

I work a lot (contrary to the popular belief that YouTubers don't do anything) so I've become very close with the people I work with. I used to think that I didn't need friends because I had Aslan and my family, but that is simply not true. There is nothing better than calling one of my mates and meeting up for dinner or a shopping session. Friendships are important to me because they allow me to have an outlet away from my home life. I also love hearing about other people's opinions and learning about what's going on in their lives. Bottom line: friends make life more interesting. I'm in a really great place with friendships at the moment, and I've found friends who accept me for who I am and I accept them. It's so cool!

Dear Zack

I wanted to carve out a special section in this book for one of my best and oldest friends, Zack. I met him in the first year of high school and we became inseparable. My first memory of him was one day in math class (my least favourite class). Our math teacher had zero control over the students and we all saw this as an opportunity to dick around as much as possible. Out of nowhere our math teacher screamed, 'What exactly do you think you're doing?' I turned around and Zack was sitting underneath his desk getting his hair cut by a girl in our class. His beautiful curly hair was falling to the ground as the entire class erupted with laughter. I needed to get to know him.

It took us a year or two after that to become close, but once we did I knew it was going to be a 'for ever friendship'. He's one of the smartest people I know and he taught me so much but, most importantly, he taught me how to love myself.

We used to get incessantly teased by people at school asking if we were dating. I adored him and he adored me, but I think both of us truly valued our friendship for what it was and neither of us wanted to complicate things. We went through everything with each other – good times, bad, awkward times. I shared with him my body-image struggles, my fears, my dreams, my views on society. We were partners in crime! He gave me sanity.

I still look at Zack as one of the best people to ever happen to me. Recently, Zack and his father came to London and we had a lovely lunch together. Although so many things separate us (the Atlantic ocean, relationships and time), we are still the same people. He has grown into a wonderful human and I must say, he's pretty hot too (he will be so embarrassed by this comment).

Dear Zack,

Thanks for 'getting me', thanks for making me laugh, thanks for understanding, thanks for wearing Converse every single day of your life, thanks for sharing my love for chocolate milk, thanks for showing me The Weakerthans and Mice Parade, thanks for always being respectful, thanks for giving me the silent treatment when I piss you off, thanks for always telling me the truth, thanks for taking me out for my birthday and not getting mad when I hated all of the food at the restaurant, thanks for never judging even my darkest emotions, thanks for having faith in me, thanks for hanging out with me for hours in front of the popcorn stand when I was bored at work, thanks for getting lost with me, thanks for loving Canada so much, thanks for skipping school with me, thanks for building blanket forts in my basement, thanks for making me feel calm just with your eye contact. Thanks for *everything*.

Love, Estée

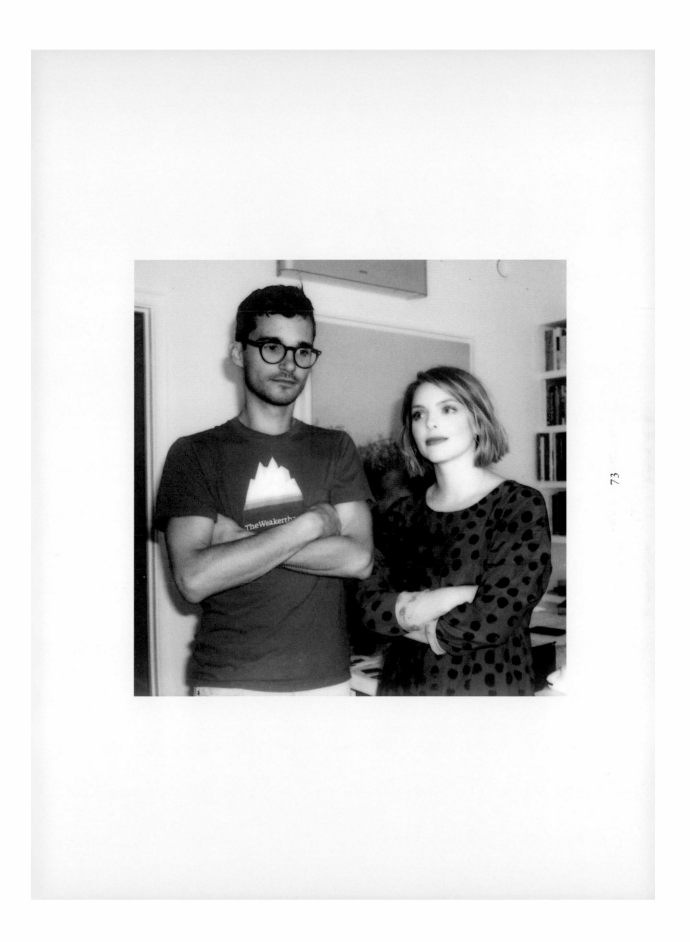

Amelia

I've had one friend from the very beginning of this blogging journey and her name is Amelia Liana. I couldn't possibly write this book without mentioning her because she is my rock.

Not only is she beautiful, smart and hilarious, but she knows me better than I know myself sometimes. She's probably the only person in the world who likes to talk about absolutely nothing as much as I do. I don't talk on the phone with anyone as much as I talk to Amelia.

We laugh together, we brainstorm together, we support each other and we respect each other. The other day we were grocery shopping (we should probably just get married, I know) and she started tearing up out of the blue and said, 'Thank you for always being honest with me. I really appreciate it.'

I'm not very good at expressing how much things like that mean to me, but I think that was one of the nicest and most sincere things anyone has ever said to me. There is no competition between us, there is no weirdness – there is only love. We are two totally different people with different life experiences and different paths, and I absolutely love that we have found this middle ground that allows us to be uniquely connected to each other's emotions. She's one of my best friends and I would not be where I am today without her. I wish you knew how many breakdowns Amelia has got me through, because this girl deserves a medal. She is also the person who told me I had major VPL (visible panty line) and introduced me to the world of thongs – now that is a real friend.

Thank you Amelia for always being there for me, no matter what the time of day, and always being (brutally) honest with me. I hope I can be as positively impactful on your life as you have been on mine and I know we can survive anything as long as we have each other on speed dial.

Girl love

To me, girl love is all about supporting, encouraging
and inspiring other women. It can feel very scary to put
yourself out there creatively and assertively, but with the
support of other women around you it becomes a much
more comfortable thing to do. I'm lucky that I have
an incredible support group between my family, friends
and my wonderful viewers.

When I get an email from someone saying that I made
a difference in the way they feel about themselves or that I've
somehow inspired them to do something they were scared
of doing, it feeds my soul. Always try to support women
who are doing something cool, even if it's as small as telling
someone they look fierce in the lipstick they're wearing.

And as for your 'competition', don't stop anyone else
from doing their thang! Some people are worth cutting
out of your life (I'm a big believer in this), but don't waste
your energy on them because feeling negative is exhausting.
There are only so many hours in a day; don't spend your
precious time and brainpower thinking bad thoughts about
others, especially other women.

Girl hate

We're told that, as girls, we should hate other girls who are as awesome as or more awesome than ourselves. Girls are consistently pitted against each other in the media and we're bombarded with the idea that there can only be one fashionable girl, one funny girl, one clever girl, etc., in a group of people. All thanks to some awful movies, TV shows and magazines showing us women competing for the same man, the same career and/or the same best friend.

We've all felt threatened by other women at some point in our lives – it's natural. That girl who struts around like she's the hottest thing in the room? It's Confidence. I love confidence!

It's not a crime to feel great about yourself. Hell, that's what this entire book is about! So how come when we see a woman feeling great about herself our instant reaction is to be jealous? Perhaps you fear she's the better version of you? Think about a girl you really hate. Why do you hate her? If it is a case of jealousy then that's actually great news. You can do something about that! Get to know her. When I've been in this situation and felt this way, we've ended up becoming really great friends. It's hard to admit when you're jealous of someone, but once you understand why you're jealous (thanks to all of this bullshit media we're drowning in) it gets a little easier to chew. If you meet for lunch and she's a total butthole, I give you permission to remain enemies.

Three
—
Work

I was always deeply consoled by the thought of life beyond childhood. I think it's because I always felt like I didn't fit in with the people around me and I had hope that my time was yet to come. I was constantly talking about how much I wanted to grow up and have my own house and live my own life. I never had a definite vision of what I wanted to do career-wise, but I did know that I wanted to do something I adored. I would daydream about wearing high heels to a meeting room and have a reason to own a briefcase (now I usually refuse to wear heels and have nothing to store in a briefcase). Thanks to my mom's support, I also had no limitations; I had no rules or anchors holding me back and I will always be eternally grateful to her for that.

My younger brother was my best friend growing up and we had the greatest time doing absolutely nothing. We used to try to 'dig to China' in the park across the street during our summer vacation from school. We would wake up early, run across the road in bare feet and start digging, breaking only for food. We would dig so deep I could stand up straight in the hole. Eventually my mom would make us come inside for dinner so we would reluctantly leave the park only to discover the next morning the hole had been filled in. Disappointed, but not defeated, we started digging again.

As that bare-footed, sand-digging little girl, I always had this mentality that anything is possible and nothing could stop me. I knew from a young age that there would always be obstacles standing in the way of my dreams (probably because I watched a lot of inspirational chat shows) and I believed that hard work would get me to where I wanted to be. When you get knocked back, get back on the horse and try harder. There is something inherent in me that gives me the strength to always keep trying – there is always a solution.

Clouds fascinated me too, and it always perplexed me that I couldn't touch them even though they looked so close. I used to get on swings and stretch my hands out to touch them with no luck. Now, when I'm flying through the clouds on my way to an new adventure, I always think back to those hot summer days lying on the warm grass dreaming of touching the clouds. My little self would be so proud for persevering through all of the obstacles life put in my way. Anything is possible with passion, commitment and hard work.

I have had a job since I was 15 and could legally get one. My first job was at the Canadian fast-food institution that is Tim Hortons. I was SO excited about it, until I picked up the uniform and the hair net. How can you make a hair net and visor look good? It's impossible.

I couldn't wait to start making some money of my own because my birthday and Christmas savings weren't cutting it. My first job also helped me really understand the value of a dollar. I thought I'd be able to afford all of the things I wanted and more! Unfortunately, the fast-food industry doesn't pay that well. But it was work and it was still a lot of fun because some of my friends worked there as well. And I got one free doughnut per shift. Perks.

My time at Tim Hortons was short-lived and I got fired for the first and only time in my life. One of my friends came in and ordered a medium coffee and instead I gave her a large size. Apparently that's known as stealing, kids, so do not do it!

I got a job at a popcorn kiosk in the local mall, which was my favourite time of being a teenager. I worked alongside two girls who were slightly older than me and they were the coolest girls I had ever met. They were edgy, they had piercings and they dressed differently to everyone at school. They were probably the only two girls at my school who had messy short hair, which is perhaps my

inspiration for my signature hairstyle! I felt cool for the first time in my life (if only by association).

I worked at the popcorn stand for two years. On breaks, I'd hang out by the dumpsters with the other food court crew. These were my Breakfast Club moments. We would make weekend plans, I would fall in love with boys who were way too old for me and, in spite of how cold Canadian winters are, you would always find a select few huddled in a corner smoking. It was everything I thought being a teenager was about.

When the time finally came, I couldn't wait for school to be over. All of my classmates were weeping in the hallways, while I was skipping my afternoon classes so it would be done sooner.

I skipped a lot of classes in high school, but especially in the last year. I failed math three times and dropped out of summer school. While my attitude towards school was one of 'ugh, get me OUT OF HERE', I still managed to do well in every class except math. I loved English and there was a rumour that our teacher graduated from Harvard (this was a big deal for the students at our school because I don't think most of us knew anyone who had gone to such a prestigious university). I also liked art history and geography, but I never felt wholeheartedly passionate about any of these subjects. I knew I was going to go to university (it had been drilled into me since a young age that I was smart enough to go), but I was more looking forward to my new surroundings and classmates rather than what I was going to study.

On the last day of high school I walked to my car (1998 Kia Sportage for reference), put the key in the ignition and I felt free. This was everything I had ever wanted!

I blasted Led Zeppelin from the car stereo and sped out of the parking lot faster than a lightning bolt. God, it felt great.

But what the hell was I supposed to do with all of this freedom?

After the summer, my university course began. I knew immediately I didn't like it. I tried my best to make the most of the experience but, truthfully, I was extremely homesick (I was living in halls) and felt like I was the only person not having the time of their lives. I had built up university as finally being my time to flourish, so when I felt bored and uninterested I became very stressed out about finding my vocation. I then enrolled to interior design school, but sadly I didn't like that either. I felt lost, but I decided to finish the course anyway and figure out my next game plan. I was still finishing this interiors course on that fateful night I met Aslan, so if there was ever a chance to drop everything and move to a new country it was now!

From Aslan

Dear Estée,

It's difficult to explain what moving abroad really means to a person's life. It is obviously a huge change but just to say that seems not to do it any justice. Unless you have done it yourself, it's easy to overlook just how much of an upheaval it is – it is a change of literally everything in that person's life. I remember moving to the UK at the age of nine and, even though I was just a little boy who was more focused on all the sweet new Pokémon cards, I still understood that my family was undergoing a very significant event.

It is much easier to take and absorb this change when you are nine years old than when you are an adult; kids at that age are like sponges. I made new friends quickly and forgot about the old ones, and the English language seemed like no problem after a few months of practice. When you are an adult, though, those friends you had back at home are not so easy to forget, and neither is the family you are leaving behind. This is why I have always been so amazed by and proud of you. As someone who had never done much travelling and was self-admittedly a major homebody, to move to another country is a brave and life-changing thing to do. I am extremely glad that you did have the courage to do it because I'm not sure I would have done if I were in your shoes and we would not be living the wonderful life that we do now.

It is funny looking back at how things were when we started living together in Cambridge; I don't remember half of the things you talk about when you look back on that time, and I cannot lie and say that I was in tune to a lot of the feelings that you were having back then. I'm a little emotionally dumb that way and my levels of empathy are sometimes lacking. While I could understand that it was very difficult for you to be suddenly so far from home and so isolated, I just don't think I really understood how difficult things must have been for you at that time.

Things for me were going just fine – great, in fact. It was my last year at university and I could not wait to finally get out of the small suffocating town that I had found myself in for my final three years of education (academia has always been a boring necessary evil for me). I was whizzing around town on my bike, taking pictures of the tourists taking pictures, and enjoying hanging out and being with you.

I remember when you first started expressing an interest in the world of online beauty and make-up blogging. I thought it was great and that you should definitely give it a go as it was just such a natural continuation of what we were already interested in. I loved taking photos, I loved watching YouTube videos and we sent each other our own private little vlogs on YouTube when we had done long distance. So for you to go into the world of online beauty blogging seemed like a very natural thing to do. I remember setting up your first video using an actual handheld camcorder. You were so nervous and I didn't know whether to stay in the room or to leave. I also remember helping you figure out how to use a camera properly so you could take those first nice-looking flatlays for your early blog posts.

It all seemed so easy and just fun for me, but even back then from that first video and blog post it was a little different for you. You had hope of what the potential could be and, although you might not have admitted

it at the time, blogging was more than just a bit of fun. You have a very intuitive personality and, if you ask me, I think that's why you were so motivated and were able to push yourself out of your comfort zone. Blogging also gave you the confidence boost that you needed during the first difficult year in the UK.

The first time you went up to London alone for a beauty blogging event was quite a momentous day because I knew it was a big deal for you to feel confident enough to do that alone. I was so happy that there was something in your life that was pushing you like that in a positive way.

Fast forward to now and to say you have come a long way would be an understatement. You have changed and evolved so much from that nervous girl in a Cambridge daze. To see how far you have come and the strides that you have made is so satisfying; you faced those fears and anxieties head on and conquered them in your own way – a new, exciting, digital way only possible in the twenty-first century. It's inspiring to see you use what you have learned along the way to encourage others to succeed in the way that you have. I want to say that I am proud and of course I am, but that just does not seem enough. I am not really very good at explaining my emotions but, yes, I suppose the word is pride. You have been able to push along and keep on going, which is something that takes real strength and character, and I am very proud to have someone like that in my life.

People always ask how much I help you and what my role has been or is in your work, and I normally make a joke about how I am your professional Instagram husband. But that's all I really am in this. I provide you with support and technical help, but you have always been the star and talent, and always will be.

Love, Aslan

Finding your niche

I knew nothing about computers when I started blogging, so Aslan helped me set up my first website. Since I was going through such a tough time emotionally when I first moved to England, blogging was a brilliant distraction and fun hobby. It was something I enjoyed and it didn't stress me out, so I put as much energy into it as I could. I blogged multiple times per week about what I was up to, sharing a few recipes and beauty products I loved.

Blogging helped me through that dark time in my life and gave me the confidence to get out into the real world more. So while I still loved blogging at the weekends, I also started studying psychology at university part-time through distance learning at a Canadian university. As I've mentioned before, school was not my favourite thing, but I thought maybe I could do well at an online degree since I loved to learn. Besides that I also started working two part-time jobs, so I became busy pretty quickly! My blog definitely didn't become an immediate success, but what I found important was the friends I was beginning to make.

I went to some blogger events a few months into my blogging career to meet other bloggers face-to-face, and I started to feel like I had a bit of purpose. I had noticed that a few of my readers suggested that I make YouTube videos to go alongside my blog posts as it was a much easier way of describing products and expressing yourself. Of course I watched YouTube videos, but I was nervous to do my own. I had never been in front of a camera before and I felt like I didn't have much to say! It's funny because a lot of the people I meet today tell me they're too nervous to start a YouTube channel because they don't have anything original to offer. You can guess my response to that. After perusing videos for a while I decided I didn't have much to lose.

When I started making videos I resolved to try not to keep up with the trends, but to talk about things that I personally loved. It was scary; it was the first time I'd ever fully trusted my gut.

I had zero qualifications when it came to the beauty and fashion world but I made that my angle. I made it clear from the start that I had absolutely no idea what I was doing, but I wanted to learn along with anyone who cared to join me and watch my videos.

It took me about 12 hours to film and edit my first video (something that might take me three hours now) and there were tears. I was terrified and frustrated with myself. I eventually published my first video about some new make-up brushes I bought. It was so boring!

But then … five views, six views, seven views – the adrenaline hit me! It's so hard to explain the rush I get when I publish a video, but even after all these years and hundreds of videos I still get the same feeling. *It's fun.*

As I started making more content, I got more and more interested in beauty and fashion. At first beauty was just an enjoyable outlet that I could distract myself with, but the more I learned the more I began to care about the different lipstick textures available!

Eventually, I no longer found it daunting to stay on top of the latest and greatest beauty and fashion innovations because I was doing it at my own pace. I was also learning all the beauty lingo and 'hitting pan' – coming to the end of a product – was a massive deal. I had immersed myself in the world and I wanted more, more, more, MORE products to research. *Was I becoming a real beauty guru?* I felt like a fraud.

What I've learned is that everyone at work feels like a bit of a fraud and that's OK. It might be interesting for you to learn that every single successful blogger I know battles with this.

Even the most successful people are still trying to figure it out day by day. The way I dealt with becoming more known in the industry was to slowly build my confidence by learning at my own pace. I said yes to a lot of opportunities because I knew they would teach me something and I was always trying to get better.

Our time in Cambridge was up after Aslan graduated from university, so we packed up and moved to the big smoke – London! I had to learn a new city all over again, but this time it was way more exciting. I guess I had become a lot more comfortable in my own skin because of blogging, and London was definitely the place to be.

It seemed like all of the bloggers in London knew each other and I thought it would be so cool to be part of the beauty blogger crew. I started a new job in Notting Hill at a furniture store, but every single second of my spare time was poured into typing up posts, and filming and editing videos. I would usually work from 7am–4pm, get home around 6pm, study from 6:30–9pm and blog from 9pm–midnight or later. I was committed to blogging and made it a massive priority because I loved doing it so much.

After a year of that I started feeling very burnt out and I knew something had to go. At that time I was starting to gain more views on my videos and was making a bit of money through the advertising on my sites. I told myself I would commit to blogging full time for one year. At the end of that year, I would reassess the situation and figure out a plan. I quit my jobs and university classes and dove head first into everything blogging-related. It was the single best thing I could have done for myself because I became my own boss.

Bossy

The first few months of being my own boss consisted of me not doing much work and spending a lot of time watching TV.

Eventually I got bored of watching TV and I got into the rhythm of creating a schedule for myself. Self-motivation is key if you want to be self-employed! There is no one telling you what to do, when to do it or how to do it.

When you work from home it is very easy to stay inside your house for days without ever feeling the fresh air. Of course it is convenient, comfortable and flexible, but I have certainly struggled with loneliness. Making online content is very much me, myself and I, and for a long time my only friend was the postman. I started to feel very trapped and uninspired. Because of this I learned the importance of getting outside regularly.

THINGS I DO TO STAY MOTIVATED

1. Reggie and I get outside and go for a walk a few times a day. We both get fresh air and it makes me take regular breaks
2. I change location: I go out to a café with my laptop. I work so much better when I don't feel so confined to my desk and my content has definitely improved since doing that
3. I make lunch plans with my friends and just generally make excuses to get out into the world more! Taking time for a proper lunch break really improves my creativity, productivity and helps me manage my stress levels

Besides teaching me about self-motivation and self-discipline, my job has given me some guts. I was a scared little lamb when I started working for myself. I let other people push me around and take advantage. I've learned that if someone asks you a question you don't feel comfortable asking you're well within your right to say, 'I'd rather keep that to myself' or, 'I'd rather not answer that'. Saying 'no' was so hard for me in the beginning because I didn't want others to think I was difficult to work with or I was being a 'bitch'. Now saying no is literally one of my favourite parts of my job because it reminds me that I'm in control and no amount of persuading can convince me to do something I'm uncomfortable with.

Shortly after I first decided to work full-time at blogging I agreed to do some paid work with a brand that shall remain nameless. Once I had completed the job they refused to pay me. I couldn't call my mom to sort it out for me, so I had to take charge. After some forceful emails and phone calls back and forth I got my money. That experience was only partly about getting paid. It was also about taking control and learning to stand up for myself. Little things like that felt so huge to me at the time, but I was learning how to run a business and those lessons are priceless.

TOP TEN THINGS I'VE LEARNED THE HARD WAY

1. If you want something done right, do it yourself
2. Trust your own instincts
3. Not everyone is going to be happy for you
4. Don't underestimate yourself
5. Follow your heart
6. No one is going to care about your business as much as you do
7. You are the boss of yourself
8. Fake it till you make it
9. Take a day off every now and then
10. Don't knock it till you've tried it

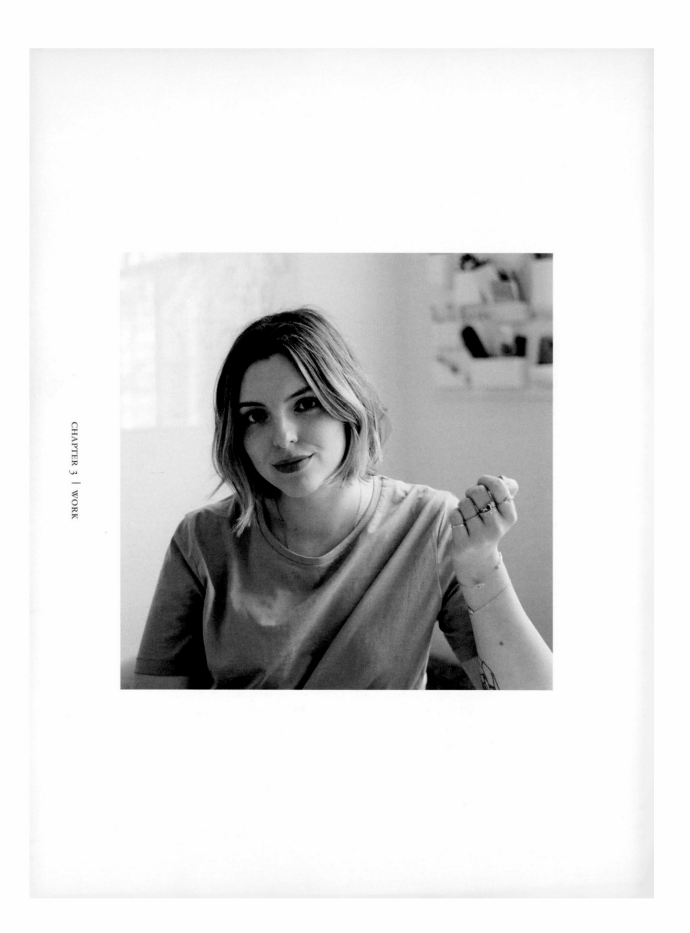

Female empowerment

For a long time I didn't understand what feminism was all about. All I knew was that my stepsister Danielle, who was doing a degree in women's studies, was definitely one of them and I thought she was pretty cool. She introduced me to the music of awesome women like Ani DiFranco, Fiona Apple and Tori Amos, which was life-changing in itself.

It's hard not to be inspired by so many women from before my time, as well as the women now who are doing incredible things. I have so much respect for Oprah, who has dedicated her life to helping other people better themselves. She has taught me so many valuable life lessons that I wouldn't even know where to begin.

I've had the pleasure of meeting Caitlin Moran, who has opened the door for conversations that used to happen only behind closed doors. Her outlook on the future of feminism is truly inspiring and she has a way of explaining things that feels inclusive to everyone.

Tina Fey is another woman who I adore. She makes being funny look so damn easy and I admire her for using humour in a way that also shines a light on some serious issues such as girl hate.

I'm inspired every day by a friend of mine, Ingrid Nilsen, who is also a content creator on YouTube. Ingrid has such a unique approach to all of the content she creates and she stands up for what she believes in with her work in the LGBTQ+ community. She is brave, inspiring and one of the most driven people I have met. I know for a fact she will continue to do outstanding things.

Of course I adore the Queen. Queen Bey that is. As well as Emma Watson, Amy Poehler, Ellen DeGeneres, Chelsea Handler, Shonda Rhimes, Lena Dunham, Coco Chanel, Lisa Eldridge, Madonna and loads of women in my everyday life. This is just a very short list of who has helped pave the way for all women to feel empowered.

We have to empower other women to do great things and give them the courage to be who they are without the fear of being torn apart for it. If we can't support them, gender inequality will only grow and no good will come of that. So it's time to stop judging others. We're not in competition with each other; there is room for us all to flourish. If someone feels empowered by something then let them be empowered by it.

Strong woman vs beauty guru

For the past couple of years I've really struggled with the idea that I could be a strong woman and also make a living from talking about make-up all day. I felt like perhaps I was limiting myself to something superficial, which is not what I set out to do. In the beginning it was just a bit of fun, but, as the views started getting higher and my audience became more invested in what was going on, I realized that I have to be accountable for the messages I'm sending and how I want to be portrayed.

There was definitely a time in my YouTube career that I started to wonder what the hell I was doing with my life. I wanted my work to reflect that I was more than just a materialistic human (as much as I love lipstick), but I couldn't figure out how to translate that into content my audience would enjoy.

My response was to get rid of stuff: clothes, cosmetics, random papers in my desk and more. I was speaking to

my mom about feeling suffocated and my need to declutter my life. She said that she only has one make-up bag and I was so envious! I can barely remember a time when my life didn't revolve around trying new products. For a short while I stopped wearing make-up; I wore pyjamas all the time and made a little personal stance against the industry. I was over it. I also went on a massive clear-out mission (of course I made a video about it) in the hope that it would give me some clarity on what I was meant to be doing.

While I was going through my clearing-out process I received loads of criticism. Understandably, people came to my channel for beauty videos and when I wasn't delivering some thought I was being lazy. What was actually going on was that I didn't know how I should carry on with my channel. I felt like I had said everything I needed to say about beauty products and I was bored. I'm someone who needs to evolve and I had felt so stagnant in what I was doing. Although I was getting negative feedback, the clearing-out process helped me so much personally. Along with purging physical items, I was purging a lot of voices inside my head that were telling me to conform to other types of beauty content on the platform. I came to terms with the idea of losing a chunk of my audience because I have always made content from an authentic place and I didn't want to lose those roots. And this was my way of learning how to have fun again.

Around that time I attended an event back in Toronto called Buffer Festival. It was a really inspiring few days because I got to meet so many viewers from my Canadian homeland. Go Canada!

It's so easy to let yourself become deflated after criticism, which for me came from looking at mean comments on a computer day after day. But I've come to learn that those people are a very small proportion of my audience. All of the people I have met either out and about or at events have been uplifting, passionate, excited and believe in what I'm doing. Meeting people who watch what I'm up to is like 20 shots of espresso and the buzz keeps me going for months!

If I listened to the people in the beginning saying that blogging was a fad or I was being silly, I wouldn't

be where I am today. I continue to make content for the people who believe in it and I refuse to stoop down low to the haters and create things in hopes that they might love it because they hate everything anyway.

I had an open conversation with loads of people who came to the event in Toronto. We spoke about the process of changing online, and what they did like versus what they didn't like about my new approach to making videos and it was really helpful. I came away feeling as inspired as I was when I first started making videos and I was ready to take on some new adventures. Besides that, I made friends with my beauty products again! However, this time it was on my terms.

It's important to do things that you are passionate about and, for me, I was passionate about a lot more than just beauty.

I realized through this process, that the beauty products themselves have never been the thing I liked about beauty. I like the way red lipstick looks, but what I like even better is how red lipstick makes me *feel*. I've realized that I can be both an empowered woman with a message *and* feel great when I wear winged liner. These two things are not mutually exclusive! I think it's so badass that lipstick or eyeliner or whatever gives me this magical power and makes me feel like I can conquer anything. This feeling that I get from beauty I get from lots of things, and that is what now inspires every video I make.

When I was going through a really tough time, trying out a new mascara or perfume genuinely gave me pep in my step. If I can provide someone with the same comfort, I am beyond thrilled. I want to create a place where someone can go at the end of a rough week and have ten minutes to forget about the stresses of their day.

HOW TO FIND CREATIVE INSPIRATION

For me, boundaries are very important when finding my creative inspiration. If I'm feeling drained because I haven't been switching off from work mode then I will most likely not be in the most creative mood.

When I'm having time to unwind with friends or see a movie that's when I feel the most inspired. I suppose it's strange when I put it that way because that's my time to not be thinking of work stuff, but that's just the way my brain works.

Things like travelling, and reading books and specialty magazines like *The Gentlewoman* and *Cherry Bombe* all inspire me in different ways. Even going to a different café than I normally go to can be inspiring. I love putting myself in unfamiliar situations. If that's not possible and I'm stuck at my desk then I like to take a few minutes to browse my favourite websites and take note of things that I love about them. Working in a creative industry means that staying inspired is very important and it's not always easy! The best tip I have is to take regular breaks and then get back to brainstorming.

MY CREATIVE WORKSPACE NOW

My office is my happy place, so if my desk is a mess I am
a mess. I try to always have my desk completely clear except
for my laptop (of course), a few crystals and a candle.
If I have loads of stuff around me it stresses me out and
I can't work well.

I like to have plants in my office, like my aloe vera
plant that just keeps growing! I also have a wall covered
with loads of pictures and little keepsakes that make me
smile. In general I just try to make my office a positive
environment so that when I'm on a phone call where
I have to lay down the law I can hang up the phone and
bask in some positive energy.

I also need to have as much natural light as possible
and, thankfully, I have two big windows in my office to let
the light in. For now, working at home is going well for
me, but hopefully one day I can get a real office space and
I can have fun with the decorating process all over again!

Four
—
Beauty

Until that moment I went online to search
for new make-up to cheer myself up,
I had never heard of beauty blogs before,
but I found them fascinating.

I loved that they were blogs written by real people with real opinions. I started my own blog because I thought it would be a great way to meet new people with similar interests and it was a good distraction from the struggles I was going through at the time.

Since then, I've made lifelong friendships, tried things I never thought I could do and gained a real sense of self – and it all began as a fun weekend hobby and some new beauty products. I will never forget how this whole thing started. Without people watching and reading my work, I would not be able to have what I consider to be the best job in the world.

My thoughts about beauty have changed so much throughout my life. I used to think it was so unfair that the meanest people I knew could be so gorgeous! Now I still notice if someone has gorgeous hair or an amazing smile, but I'm much more likely to find someone truly beautiful if they're a nice person and treat others with respect. One of my all-time favourite books is *The Twits* by Roald Dahl and this passage sums up perfectly what I am trying to say:

'If a person has ugly thoughts, it begins to show on the face. And when that person has ugly thoughts every day, every week, every year, the face gets uglier and uglier until you can hardly bear to look at it. A person who has good thoughts cannot ever be ugly. You can have a wonky nose and a crooked mouth and a double chin and stick-out teeth, but if you have good thoughts it will shine out of your face like sunbeams and you will always look lovely.'

Niceness radiates from the inside and shines out through the eyes, which is why it always freaks me out when people can't maintain eye contact. As clichéd as it sounds, beauty starts from the inside.

Before I got to this point of realization, there was a period of time at high school when I was so obsessed with being a cool girl. I was so desperate to fit in with the prettiest girls. I started to mimic all of their actions, talk like they talked, wear what they wore, and for the first time I felt like I was finally fitting in – it was all very *Mean Girls*. Once, I was doing my make-up with a few girls in the school bathroom and a younger girl asked us why we wore so much make-up. My friends pounced on her, suggesting that maybe she should wear more make-up to cover up her ugly face blah blah. Anyway, I was standing off to the side watching this poor young girl crumble and I decided that was the end of it. This wasn't me and no amount of attention from boys or the other popular girls would make bringing someone else down worth it. I have always regretted not saying something to that girl in the bathroom and it was an important lesson for me.

This might all sound kind of a contradiction coming from someone who's built a career around make-up and fashion, but my stance has always been that these things simply enhance the inner beauty. If you feel great on the inside, why not extend that great feeling to the outside?

It's an easy concept for me now, but I haven't always felt great on the inside. I remember being as young as six years old, feeling 'fat' and thinking that I wasn't as pretty as the other girls at school. I used to practise sucking in my stomach in front of the mirror to see how I could look if I lost weight.

One day my mom came home with a notepad that read 'I may be fat, but you're ugly and I can go on a diet'. That was my comeback every time someone called me fat at school. Obviously it's not okay to call someone fat or ugly, but the people I said this to were ugly – on the inside. Looks had nothing to do with it. Sadly, I know I'm not the only person who has spent their childhood fixated on their appearance. Loads of my friends felt the same way, which is absolutely heartbreaking. We have to start talking about body image at a much younger age, it is so important.

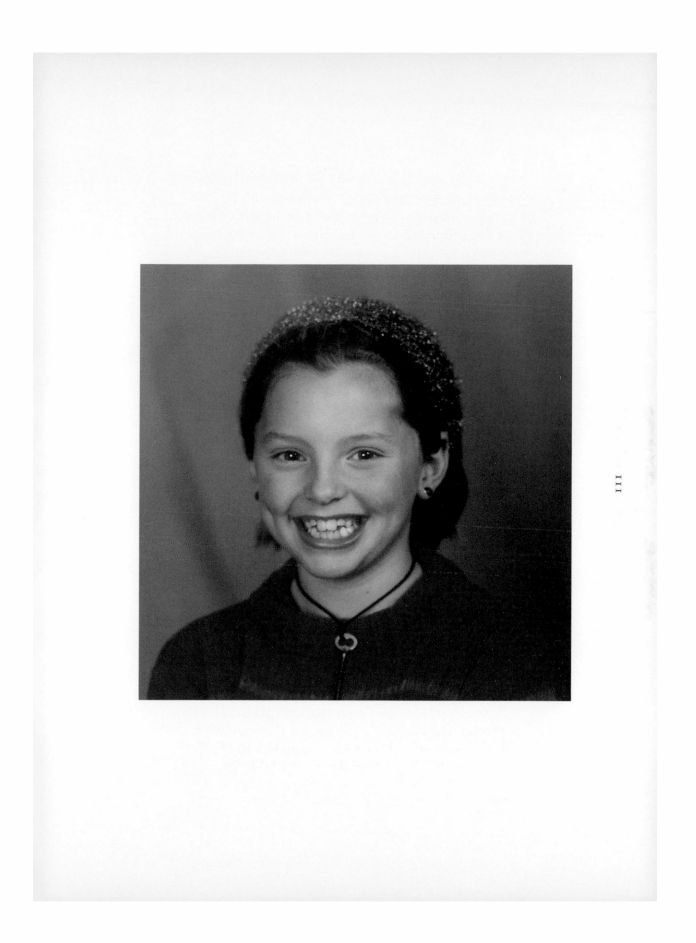

I would say I spent almost all of my teenage years not feeling pretty enough, thin enough or just generally good enough for the people around me. But later in life I came to the realization that feeling good about yourself isn't for the people around you, it's for yourself.

I'm not going to wake up tomorrow looking completely different. It started to scare me that I could spend my whole life missing out on opportunities because I didn't have confidence in myself. I missed out on so many parties and fun times because I thought I looked fat in my jeans or I thought no one would think I was cool. I've now figured out (thankfully) that the way you look is just one small part of who you are. I started focusing a lot more on who I was as a person and the rest of it sort of fell into place over time. I started reading more, watching films that inspired me, going to new places in my city, saying yes to opportunities even when it scared the shit out of me.

I was well on the way on my journey to self-acceptance when I met Aslan, but meeting him when I was 19 was the best thing that happened to my confidence. He was the first man that adored the way I looked and always made me feel beautiful. He never said things like 'if you lost ten pounds you'd be perfect', which was very refreshing! Because of this I started thinking maybe I wasn't that bad after all.

When I met Aslan I was convinced for months that the truth would come out, that he would finally admit that he doesn't find me attractive and it was all one huge joke among him and his friends, which just goes to show you where my confidence levels were at the time. Aslan could not understand why I didn't believe him, but the thing with self-esteem is that people can tell you over and over again that you are wonderful, funny, smart, gorgeous, etc., but if you don't believe it, it goes in one ear and out the other. Of course, Aslan had a major part it helping me see myself in a more positive light, but it took a lot of work on my part too.

Through pushing myself out of my comfort zone, doing new and interesting things, and meeting and interacting with new people, I finally started to feel like I was just as worthy as I deemed other people to be.

My whole world used to feel like one big competition with everyone around me. I'm no longer in competition with anyone; other people don't threaten me, I don't wish I had their life and I'm very much a woman with my own mission. I don't feel on top of the world every day, but I make a massive effort to do my best with what I've got.

Feeling good

When it comes to feeling beautiful, it's so important to give yourself permission to feel good in your skin. For so many years, I couldn't take a compliment. If someone told me I looked nice I would reply with something like 'ugh, no I'm so tired!' or 'pssh, these jeans are way too tight!'

Allowing myself to feel beautiful was so hard for me, and I think it's hard for a lot of women. For whatever reason, I felt like it was selfish and conceited to think I looked great, but actually it's the opposite. Feeling good in my own skin has made me a nicer person (to myself and others), boosted my confidence and allowed me to focus on much more important things. There is nothing wrong with looking at yourself in the mirror and thinking, 'Damn! You look great today!' Trust me and try it … and really try to mean, it okay!?

The relationship you have with yourself is the longest relationship you'll ever have. We have to work on this relationship just like we need to work on the other relationships we have in our lives. Some days will be easier than others, but just know that you are beautiful.

Feeling beautiful

Everyone feels beautiful at different times and sometimes it can be the most random situation that makes you feel gorgeous. These are my favourite moments in my life that make me feel beautiful.

1. Firstly, and most often, I feel beautiful when I take my make-up off after a long, productive day. I enjoy washing my face so much and I never rush it so that I can appreciate the process. There's something so relaxing to me about cleansing my skin and taking some time to myself to really process the day. It kind of allows me to draw a line between the work day and the relaxing evening. Along with a freshly cleansed face, I put on some fresh, comfortable loungewear and take a minute to breathe. I feel so calm and happy, which makes me feel beautiful.

2. I'm a summer baby, so I love nothing more than wearing a dress, a cool hat, sandals and a cute little bag. These are my favourite kind of days, especially in London because the sun is a real treat for us! I feel like I can relax and be myself, which makes me feel beautiful. I can pop into little boutique shops, go for a quick brunch and spend the day soaking up the sun. There is nothing better than a summer's day if you ask me. I can almost feel the sunshine on my shoulders.

3. Relaxed weekends are the best. I love hanging out in my loungewear cleaning the kitchen or organizing my office. I know it probably sounds crazy, but I actually really enjoy it. Hair up, music on, comfortable clothes … what's not to love!? I'm seriously turning into my mother because she loves to clean and I always thought she was absolutely insane. Those countless mornings of waking up to the sound of the vacuum clearly did a number on me because Sunday morning tidying is what I live for! Rock on.

4. Spending more time doing my make-up for a special event or a night out is really fun for me. I love all of the glamorous imagery of old Hollywood stars sitting at their vanities applying lipstick, and whenever I do my make-up I like to channel that glam feeling. Taking that extra time to perfect my make-up makes me feel great.

5. The little details make me feel beautiful. For instance, red lipstick always makes me feel hot. Even if I'm wearing it with very minimal make-up everywhere else, red lipstick is an instant confidence booster. I also love perfume and wear it every day, even if I don't get out of my pyjamas.

Beauty rituals that
I never miss

SUNDAY NIGHT SPA SESSIONS

Don't try calling me past 8pm on a Sunday – I won't answer! My Sunday night spa sessions are essential to my existence. Along with drinking a strong cup of tea every morning, I could not function without my weekly spa night. I crave alone time, especially right before another week starts. Giving myself an hour (OK, two!) on a Sunday evening is my idea of heaven. It's my hour to ignore responsibilities and not think about all of the things I need to get done. At first I think Aslan thought these Sunday night sessions were pointless, but the man has seen me when I miss one and it is NOT pretty. Sometimes he even says, 'Do you want to go take a bath?' if it's getting a little late on a Sunday. Don't mess with me on Monday morning if I miss out on my bath.

I light a candle, lock the door, run the bath and begin to unwind. Not only do these spa sessions help me unwind physically, but they help me work out all of those stressful or complicated thoughts I may have been dealing with that week. Shutting out the world and focusing on you is something that is not selfish, it is necessary. In my bath I always use aromatherapy oils, which calm me down – strong mentholated ones, such as Aromatherapy Associates Support Breathe Bath & Shower Oil, are my favourites. I add a few drops to my bath and suddenly my bathroom is transformed into a spa. Fragrance is extremely therapeutic

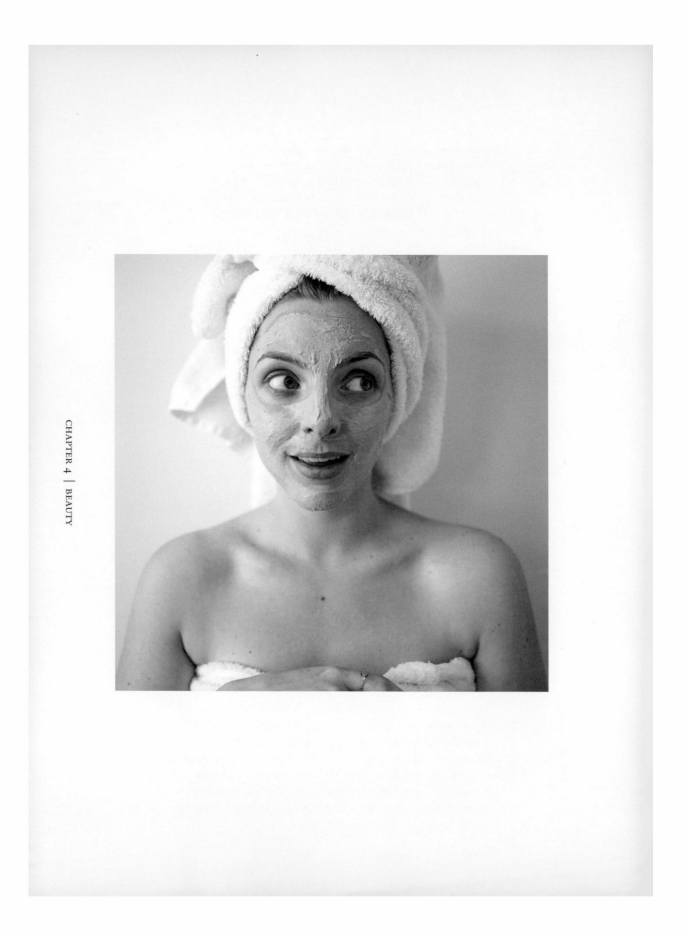

and creates a very luxurious atmosphere. Besides oils,
I love to use Epsom salts in my bath, which is an affordable
product you can find in most drugstores. They contain
magnesium (helps to improve nerve function, reduces
inflammation and improves blood flow) and sulphate
(helpful for healthy joints and skin). I usually spend around
40 minutes in the bathtub watching one of my favourite
shows on my laptop and just chilling out. I'll also use a hair
mask (sometimes coconut oil) throughout my hair. It is pure
bliss! When I get out of the bath I always moisturize my
body from head to toe, do a facemask and paint my nails.
It all goes down on a Sunday night at my house!

MID-WEEK CHECK-IN

The Sunday spa night is the heavyweight champion when
it comes to relaxation, but I like to try and maintain that
serenity throughout the week. That being said, I usually
don't have time for my proper two-hour-long ritual,
so this is just a bit of maintenance. Usually the mid-week
check in happens on Wednesdays or Thursdays and it helps
me stay Zen until Sunday (I'm a bath addict). I like to take
a little extra time taking off my make-up and maybe have
a moisturizing mask on while I do the laundry. This beauty
ritual is far less intensive and usually it's all about the
multitasking. Sunday is all about me, but Wednesday is just
a little treat while I'm doing other things at the same time.
It still gives me something to look forward to and it keeps
my skin looking refreshed.

I am nothing without my eyebrows. I have been through hell and back with my eyebrows. When I was 12, I let my friend pluck almost all of my eyebrow hairs out (thin brows were in at the time) and I spent the next ten years trying to grow them back. I thought it wasn't possible for me to have nice eyebrows, but luckily I have discovered eyebrow threading – I am a total threading convert! Since handing over my eyebrows to the threading professionals, they have transformed from young and unsure to fully-grown and confident! If you've never had your eyebrows threaded or have never even heard of it, then allow me to change your life for ever!

Threading is a way to shape the eyebrows (rather than plucking or waxing) and it allows precise control over the shape. A cotton thread is used to glide across the skin, which removes unwanted hair. It's super quick and I don't find it too uncomfortable now that I've been getting it done for a few years. That being said, I remember my eyes uncontrollably watering the first time I had it done and I also managed to sneeze all over the lovely lady shaping my brows. It's definitely not painless, but it's very minimal once you get used to the sensation. Threading grabs the hair by the root so it leaves a very clean finish and baby smooth skin. I can't even begin to tell you how much it has improved the thickness, shape and overall appearance of my eyebrows.

Besides threading, I also get my brows tinted as I have very light-blonde brows. It takes just a few minutes and it allows me to wake up with my brows looking bomb dot com. I usually go every two weeks to get them sorted out and it makes me feel so fresh! It's crazy what a difference brows make to your face. They say your eyes are the windows to your soul and your eyebrows are the curtains. Again, I am nothing without my eyebrows.

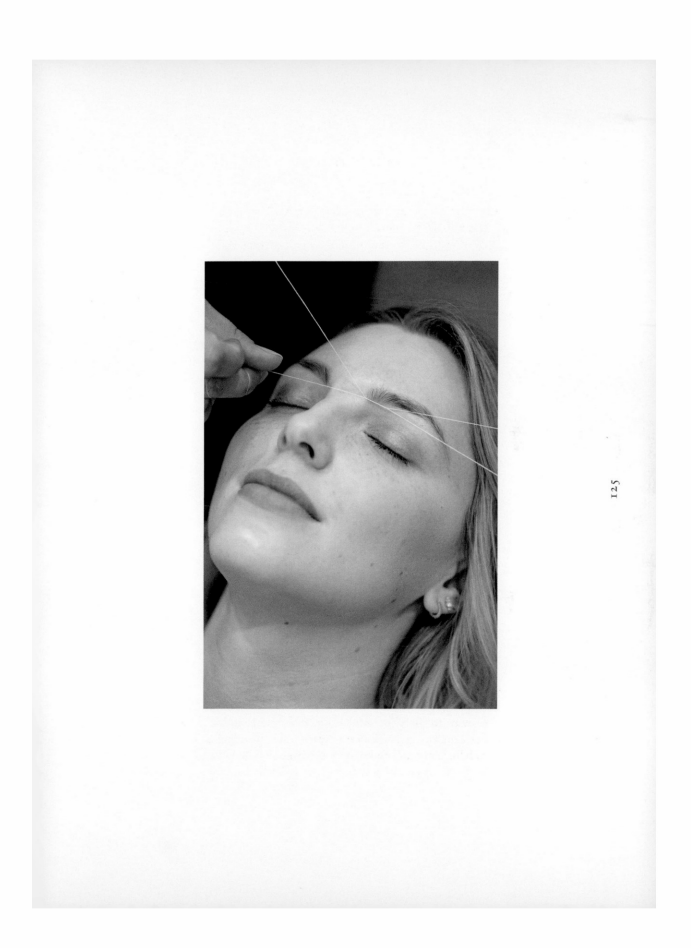

1. One thing on my beauty bucket list is to cut my hair into a super short pixie cut, but I'm not quite brave enough for that. They say that when you go through something significant in your life the first thing you should change is your hair. So maybe once I have a bunch of kids running around and I feel like I might want to run away to Nepal I'll get the pixie cut I've always wanted.

2. I have always admired women who embrace their grey hair. When the time comes for me, I would love to have white-grey hair, but sadly I don't think it's going to happen! Even my grandma only has a few grey strands dotted throughout her hair, so perhaps it's not in the cards for me.

3. I've always wanted to do a magazine shoot where the make-up and clothes were completely insane. I want coloured eyeshadow, glitter, contact lenses, the lot. You name it, I want it!

4. Nude photo shoot. Hear me out! I have always wanted to do a very tasteful nude photo shoot that was very stripped back and undone. No make-up, no hair stylist; just me, myself and I. Don't get excited, this one will probably be for my personal collection … or *Vogue* if they ask nicely.

5. Getting married isn't something I've ever been particularly interested in. I have no real desire to have 'the perfect wedding'. Aslan and I always joke that we're going to elope to Las Vegas (are we joking though?) and I do look forward to having a rather unconventional wedding with minimal make-up and hair – and who knows if I'll even choose to wear a traditional wedding dress. I just can't see myself in a big fluffy gown!

Hair

I've had short hair for a while now and I absolutely love it. I was completely terrified of getting it cut short (despite having short hair when I was a kid) but one day I decided to go for it. It was almost an instant attitude change for me and I saw myself as a totally different person. I never thought I was one of those people who hid behind their hair but I totally was! I desperately wanted to have long, luscious hair, but I have very fine hair and it always ends up looking straggly at the bottom no matter how well I take care of it. I absolutely adore the way long hair looks and maybe I will try growing it out again one day, but short hair has changed my life. I had no idea cutting my hair would make me feel powerful, chic and stylish. No matter what I wear I always feel like my hair is my coolest accessory. I am my hair's biggest fan! It's also great because I am absolutely useless at styling my own hair, but short hair is so easy to me. I love loose and messy curls with loads of texturizing spray. I love volume and body, and I like it to feel effortless. I want to be able to run my hands through my hair without feeling like I'll totally mess it up.

Like I said, I'm terrible at doing hair, but I've managed to
nail down a routine that works well for me. Since my hair
is so fine, it virtually sticks to my head like a helmet if
I don't style it. Not chic.

Step 1: Mousse

I remember using mousse when I was younger and it being
crunchier than … actually it was the crunchiest thing I have
ever felt. I used to put it into wet hair, scrunch and let it dry
until it was as hard as concrete. It was not the one. Mousse
has come a long way since then and it is my number one
hair product. After I wash my hair I take a golf-ball-sized
amount of mousse, rub it between my hands, then run
it through the ends of my hair. I put whatever is leftover
into the roots.

Step 2: Blow-dry that mop!

Mousse is actually heat activated, so if you don't want it
to be crunchy, whip out that blow-dryer. I don't use a brush,
I literally just dry my hair in the messiest way possible.

Step 3: Messy curls

I can't be bothered to curl every single strand of my hair,
so I grab small sections at random and curl the ends. I like
to mix up the direction of the curls so it looks messier and
I also like to mix up the size of each section. Once I've done
most of the curling I spray my hair with some hairspray.

Step 4: Texture, texture and more texture!

By this time I'm looking a lot like Little Bo Peep, which
is not my vibe. To make my hair look more modern and
messy I load it with texturizing spray. I spray every single
section with it, wait a minute and then pretend I'm washing
my hair. Ruffle up the roots and the ends and boom, done!

129

My beauty essentials

After years of trying every beauty product under the sun,
I have definitely found the products that work for me:
my beauty essentials. I always look for products that look
and feel natural on the skin. I absolutely hate feeling like
I'm wearing a heavy mask, so I avoid very full coverage
foundations like the plague. I love products that exist to
enhance natural features and do what they're supposed to do!

So let's say I had to start all over again. Imagine if I woke
up tomorrow without ANY beauty products. Knowing what
I know now, I could make informed decisions on the products
I actually need and love. Things that I use every single day
and are real stand-out products in my collection.

SKINCARE

Let's start with skincare because it's my favourite part
of my beauty ritual and definitely the most important!
I would start off by re-stocking my cleanser, moisturizer
and night-time oil. I adore MV Organic Skincare and
I have nightmares of running out of it one day. I always
have back-ups of their products because it is the stuff
of dreams and completely cured the eczema and acne
I was dealing with before I started using it. I have very
sensitive skin, so those products are perfect for me and
have completely transformed my skin for the better.
I would also get three masks: a resurfacing mask for
bi-weekly treatment (something with gentle acids),
a cleansing mask to deep clean my pores and a hydrating
mask to put the moisture back into my skin. Don't
forget the lip balm!

MAKE-UP

My day-to-day make-up is very minimal, so I'd be quite
happy to only have a few products. My essentials are
tinted moisturizer, an eyebrow pencil, a nude lipstick,
bronzer, mascara and a natural blush. On top of these,
I wouldn't want to live without a red lipstick and liquid
eyeliner for more dramatic evening looks. And can
I squeeze in a highlighter? I love to add some extra
glow to my skin!

Five
—
Fashion

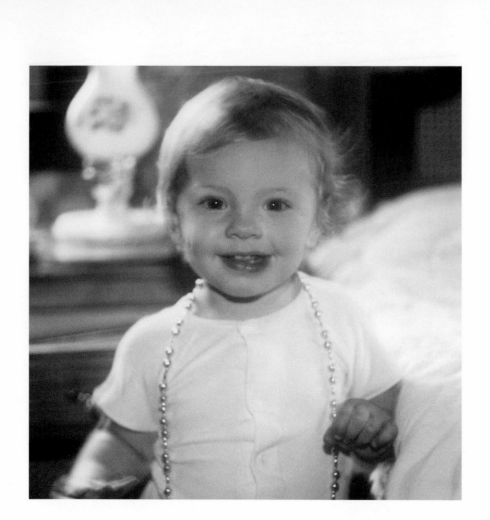

I have been writing and speaking about fashion for over five years, and yet I have never considered myself a particularly stylish person and I have always felt like I've been running to keep up with 'what's cool'.

I was a tomboy growing up and it really shocked my friends and family when they found out that make-up and clothes were becoming my world! According to my mom, I was obsessed with wearing my purple rain boots and I wanted to pair them with every single outfit, even in the middle of summer. I love that my mom encouraged me to wear whatever I wanted and if I ever have kids I will most definitely do the same. I would say that my style is actually kind of the same as when I was a kid, from the point of view that I was never overly 'girly'. I did occasionally wear dresses, but I loved jeans, sweaters and shorts. Some things never change!

There were two fashion-related events that did get my motor running. My mom took my brother and me for two main shopping trips per year, one for summer clothes and one for back-to-school clothes. One time, I begged my mom for a pair of jeans that had leather strings (like shoelaces) instead of a zip. They were my first pair of distressed jeans and they had a humungous flare (love a good flared jean). I can still visualize the way they were hanging in the store and I was so excited when the shop assistant handed them over to me to try them on. They fit perfectly and I wore them religiously. God, I will probably never feel that cool again.

I've always liked vintage clothing and I still remember the first vintage shirt I ever bought. It was a silk blouse with sunflowers printed all over it. I was very into the 60s and 70s when I was a kid (thanks to Austin Powers). One of the girls at school asked why I wore it so much and she effectively told me it was hideous and that I should get some new shirts. It was probably the first time someone made fun of something I wore and it didn't feel nice. I only wore it occasionally after that.

Around the age of 12 I went shopping in Toronto, which was a huge deal for me because I don't think I'd been there before unless it was for a concert (shout-out to that 90s Spice Girls concert). I stumbled upon a boutique that had handmade clothes and accessories and I fell in love with a very fugly shirt. It was a polar fleece that was way too tight for me and it had a massive polka-dotted flower made out of cotton sewn to the front. I couldn't

live without it and my mom reluctantly got it for me. The next day at school I wore it proudly, excited to show it off. Everyone made fun of me and I was very embarrassed. It really got to me, I threw the shirt out and that was the end of my fashion experimentation for a long time. I wish I could go back in time and shout, 'Don't kill my vibe!'

As I've gotten older, I have also been a fashion victim: if my friends wore short skirts, I wore short skirts. If they wore loads of make-up, I too would really cake it on.

I was so unsure about my own opinions and I was always searching for other people's approval. I assumed that if I looked and acted like everyone else, no one would have anything to criticize me for.

Besides not knowing much about fashion, I was very overweight and had zero self-confidence. Because I spent so many of my teenage years overweight and down on myself, I never had a desire to take an interest in fashion. I wore a lot of baggy sweaters, sweatpants and things that would hide my shape. Because I knew I wouldn't be wearing any of the clothes I saw in magazines, I basically just ignored it.

When I was a teenager I couldn't have told you a single trend or brand that I loved. I literally wore what fit and that was about it. I think a lot of that is what made me more interested in make-up, because it had nothing to do with my size and there was no risk of make-up not fitting me.

Personal style

Now I look at fashion and clothing as a major player when it comes to my sense of self. I love that I get to dictate the way I feel with what I wear. If I'm chilling, I have my go-to boyfriend jeans. If I want to go out for a nice dinner, I can wear heels and a blazer.

Fashion makes me feel powerful and it makes me walk into a room feeling like I can have a conversation with anyone. Clothes enhance my experiences. How many times have you recalled a past memory and thought, 'That was the day I was wearing that <insert article of clothing here>'? Bottom line: fashion makes me feel good about myself!

After years of experimentation, and ups and downs when it came to my body image, I would say that my style is very simple. I live in jeans and T-shirts, but I also like to dress things up every now and then. I love clean lines, beautiful fabrics, simple shapes and layers. I wear a lot of basics but I always bling up my outfit with loads of jewellery, scarves, bags, coats and, of course, my favourite accessory of them all: make-up.

I wouldn't say I'm a huge risk-taker when it comes to fashion and I'm not that into following trends unless it's something I really adore. I've finally figured out what kind of clothes I love and it feels so good!

Sometimes I feel like doing something totally out of my comfort zone (right now, for instance, I'm wearing flared overalls!). Sometimes I wear things that are so not 'me' but I think it's really fun! It brings a little excitement into my life, even on a boring Sunday when the only thing I have to do is get groceries. I think fashion and style give the mundane aspects of life a sense of purpose. It gives me something to get excited about and it's something I love learning about. I adore scrolling through Instagram and

seeing how other people have put their outfits together – usually in ways I never would have thought of!

When I used to think about style and what it meant I always looked at it in a very one-dimensional way, focusing only on clothes. I now believe that style is an all-encompassing concept for traits that make a person unique. A font can be a person's style, a particular colour, a fabric, a city … I could go on for ever!

We live in a world with a lot of choice, which can be both exhilarating and daunting. I try to see choice as a fascinating part of our existence. Everyone is free to make their own choices, their own discovery and, ultimately, build their own style.

A lot of my viewers tweet me saying, 'I saw this and it was totally your style!' and it will be a tea towel with boobs on it. This is:
1. Why I love my viewers
2. Why I love developing my style

I love looking at people on the street or checking out my friends' outfits and watching their style evolve. It's a great way to get different ideas for your own style. Fashion is an outward expression of how someone might be feeling that day. I know that on days when I feel super stressed-out I wear old baggy clothes, and I think most people who know me well know to treat me with a bit of compassion on those days.

The great thing about feeling like I know my own style is that I feel so comfortable in my clothes now. Even if I choose an outfit that I adore and everyone around me thinks it's hideous I still feel great in it. I know what I like and don't like, but I still appreciate other people's choices. There are so many gorgeous pieces of clothing that I adore, but aren't my style so they don't go into my wardrobe. I'm so happy I'm finally at a place where that feels okay! Gone are the days of me forcing myself into clothes that I don't truly love. That's not to say I won't try new things though.

The other day I bought a pair of sneakers with built-in socks, which totally blew my mind. I love trying new things, seeing what works and experiencing new ways of dressing. The first time I wore the sneakers with built-in socks I felt edgy, ninja-like and fearless. The shoes gave me an extra bounce in my step and to me that's what clothes are all about.

Style, make-up, clothes, etc. are material things, obviously, but the internal effect and confidence boost it can give to a person is immeasurable.

Something as simple as me getting out of my sweatpants and into a good fitting pair of jeans can mean the difference between a good day and a bad day.

I'm usually more productive, more positive and just feel more ready to conquer the day in general. Of course, there are days when I literally do not want to get out of my pyjamas (we need those days too), but sometimes putting in that extra bit of effort to put an outfit together can make all the difference.

My style evolution

Getting involved in the online beauty and fashion community gave me some real encouragement as I was making my transition from living in Canada to living in England. My very first outing on my own (without Aslan) was actually a blogger event where I got to meet around ten other girls who also had beauty blogs. The meet-up was in London and, at the time, I was still in Cambridge. I was absolutely terrified that morning when Aslan dropped me off at the train station. I had only been on a train once before, which was when Aslan took me to London for the first and only other time I had been to the city. Now I was faced with the terrifying task of making my way to Oxford Circus ALONE.

My anxiety was very high that day, but I pushed through it and, after a few teary-eyed phone conversations with Aslan regarding directions, I found the rest of the group. I think that was probably the first time I'd ever hung out with girls who had British accents, which was A BIG DEAL to me at the time. The fashionable women I saw everywhere I looked mesmerized me. Clothing was never something I paid too much attention to growing up in suburban Canada, but now seeing so many different textures and shapes paired together was so inspiring to me. Everyone was cool … except me. At least, that's how I felt at the time.

After that experience, Aslan suggested we go shopping for some new clothes as I had been wearing only what had fit into my suitcase when I moved. I went to Topshop for the first time and I was hooked. I felt like I had taken my first step towards being a cool twenty-something.

Living in London has taught me so much about fashion, I can't even begin to explain it. For the first few months, I wandered around England feeling like the same lame teenager. I wanted to feel good in my clothes. It was a slow progression and a lot of trial and error (key word being error), but as I started making friends and going out more, I started to see what other people were wearing and got inspired.

Still, shopping wasn't fun for me. I can't even tell you the number of times I've cried in a fitting room because of what I saw in the mirror. I look back now and think I had a beautiful body with a gorgeous shape, and so badly wish I could go back in time and tell myself how silly I was being. Years after I lost most of the weight I'd gained during my teenage years, I thought all of my self-esteem problems would be solved. WRONG! It was still debilitating for me to go into a shop and try on a pair of jeans (for fear of the biggest size not fitting me). Even today when I try clothes on, I always grab larger sizes thinking not even they will fit. Shopping was a huge source of anxiety, but I conquered that fear when I discovered online shopping. Thank God for next-day delivery! Trying things on in the comfort of my own home allowed me to try on clothes that I never would have had the guts to try on in a store. It was life-changing for me.

Besides making a couple of IRL (in real life) friends, I was reading loads of blogs by girls who were all shapes and sizes and were absolutely killing it! I wanted to expand my YouTube channel and blog to feature some of my experiences of fashion as well as beauty. This was a massive step for me (you can see how awkward I am) as I never let anyone take a full body photo of me. Many photo-shoots with Aslan ended in tears because I would shout, 'UGH, DON'T TAKE MY PHOTO FROM THAT ANGLE!' Thankfully, I have trained him how to take photos of me without giving me a double chin. If you feel the way I used to feel about myself, I want you to start stepping out of your comfort zones! If I can do it, trust me, so can you.

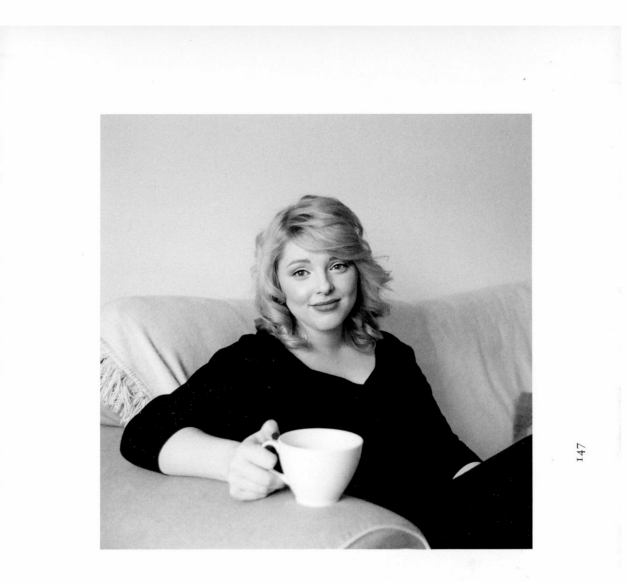

Not everything I wore back then worked all of the time, but I was enjoying the process of trying out new clothes and I was managing to not take it so personally when things didn't look good on me.

Wardrobe staples

I've found the most useful thing for me when it came
to developing my style was to find clothes that all work
together. It's important that I have a wardrobe of clothes
that somewhat go with each other. For example, in a big
rush I know I can wear any of my jeans with any top I can
find in my wardrobe and pop on a leather jacket. That's my
go-to outfit when I can't be bothered to think of something
more interesting. I think it's so handy to have these simple
go-to outfits that you know work and that you feel good
in. Makes things a lot easier, especially in a hurry.

My style is casual – I hate feeling overdressed. I feel
most comfortable in jeans and a T-shirt so I refuse to
deprive myself of that. Most days, that's exactly what
I'm wearing, but I also like to spice it up with a cool pair
of boots and a killer leather jacket. And colour! I used
to hate wearing bright colours but now I love it.

I can get away with wearing this uniform on most
days, but sometimes I need to be a little more dressed
up. For those occasions I'll wear some cool leather-look
leggings or chic trousers with a lightweight silk camisole,
again paired with my leather jacket.

I have a few form-fitting skirts in my wardrobe for
special occasions, which I will again pair with cool ankle
boots and my leather jacket. You're probably sensing my love
for leather jackets: I could not live without them. They make
me feel so badass, but not too try-hard. I love knitwear
and I have loads of sweaters, which I can pair with my
jeans or leggings, and that's pretty much it. That's my style.

I try to keep my clothes very simple and streamlined, and focus more on the fit of the items. To me, having a simple and basic wardrobe is the foundation of any wardrobe and then you can have some real fun finding the more interesting pieces (although staple items are very interesting to me).

Once I finally figured out the style of clothes I feel the best in and get the most use out of, I was on a mission to find my capsule wardrobe. I had so many jeans with tears in the seams, jackets that were a bit too short and T-shirts that had shrunk in the dryer. I made a list of staple items I needed and meticulously searched stores and websites to find 'the ones'. Since these are the things that I wear every single day, I spent a long time looking for the best fitting and highest quality pieces. I didn't rush this process and I really took my time to find the perfect pieces for me.

Investment pieces vs trend pieces vs designer pieces

INVESTMENT PIECES

The hunt for my capsule wardrobe was so fun and I learned a lot about different designers, different fabrics and why certain things can cost a lot of money. Take my leather jacket, for example: I knew I loved leather jackets so I went through my wardrobe and pulled them all out so I could try them on. I had about seven leather and faux leather jackets that I had collected over the years (all from

different price ranges) and I knew I wanted to get my collection down to two: one biker jacket and a more polished-looking evening leather jacket.

After trying them all on I realized that none of the jackets I had really suited my shape that well or the quality just wasn't there. I photographed them, sold them online and used the money to buy my dream leather jackets. It took a long time to find the perfect ones, but eventually I did and now I use them both constantly.

The sorting, selling and investing process has:
1. created way more space in my closet
2. helped me invest in two jackets I truly love and know look good on me

This is why certain investment pieces are important because they'll never go out of style and you'll get a lot of use out of them. Once you've identified what your wardrobe staples are – and everyone's will be different – you've basically created your list of things that could be potential investment pieces.

Not everyone can afford to go out and buy a brand-new Burberry trench coat, but if you have a high-street trench coat and you've worn high-street trench coats for years then I'd say it's the perfect candidate to start saving up for.

Creating your perfect wardrobe takes a lot of time and effort. I identified that leather jackets were my first priority, which got the ball rolling. Like the leather jackets, I repeated this process with all of my key pieces. I went through all of my clothes and donated to charity everything that simply didn't fit me properly. Again, I made a list of what I needed and started searching for good quality items.

My staples

— Leather jackets (one for day, one for evening wear)
— Oversized coat/trench coat
— Jeans (black, light blue, grey and boyfriend)
— T-shirts (white, grey and black)
— Shoes (everyday trainers, flat ankle boots, heeled ankle boots and black heels)
— Knitwear (long-line cardigan, turtleneck and oversized sweater)
— Activewear

Pieces everyone
should invest in

— Good pair of jeans
— Good pair of everyday shoes (whether it's ankle
 boots or flats)
— Outerwear
— Handbag (not necessarily designer, but good quality)
— Blazer
— Black dress
— Underwear!

Once I had isolated which pieces I wanted to invest in, I was free to spice up the rest of my wardrobe using trend pieces from the high street. For example, I love a good slogan T-shirt but it's not something I'm going to spend a lot of money on because it's the kind of thing I'm likely to grow tired of. Same goes for a lot of summer clothes, brightly coloured sweaters or T-shirts, a cute patterned dress, etc. I recently wanted a pair of dungarees, but I knew it wasn't something I'd wear regularly, so of course that's a trend piece for me.

Trend pieces or 'fast fashion' most definitely have a spot in my closet. They're the icing on top of the wardrobe cake! They allow you to take fashion risks without the insane buyer's remorse you'd feel if you spent too much money on something you never wear. Usually the high-street shops are very quick to bring out various items inspired by the runways, but in a much more wearable and affordable way, which is great!

DESIGNER PIECES

I never in a million years thought I would be able to afford a designer handbag. I don't think I touched a designer handbag until I was about 18 years old. It always seemed unfathomable to me that someone would be insane enough to spend thousands on one stupid bag. I no longer think like that obviously, but let's rewind a bit.

My first proper designer item was gifted to me by Aslan's Mom on my 21st birthday. It was the Mulberry Alexa bag, which I had been pining over for months. I remember opening up the big green Harrods box and wondering what could possibly be inside. 'Maybe some really fancy towels?'

I lifted up the tissue paper and there it was. My beautiful brown faux-crocodile bag. I looked at Aslan in awe and he looked at me as if to say, 'It's for you!' I spent all afternoon staring at the bag on my coffee table and rearranging how I'd store all of my items in there. I couldn't wait for the next day to arrive so I could take it on its first outing.

The feeling I had as I took my first step outside was one I will never forget. The bag was mine! I got to wear it and take it with me anywhere I went, and treat it with respect and love (potentially too dramatic for you but I seriously adore this bag).

I can't quite pinpoint why designer bags make me (and so many other people) feel so good, but I think there are a few reasons. Firstly and simply put, they are beautiful. Whether it's a bag or a designer scarf or a wallet, if you adore it and think it's beautiful then you will exude pride. Secondly, they're exquisite quality. I carried that bag and that bag only for almost two years and it still looks almost as good as the day I received it.

Designer items like handbags, scarves and shoes are so special, and when you have something that really means something to you it's no longer just a handbag. Let's not forget about vintage designer items either. I have a pair of vintage Dior sunglasses with blue lenses that look modern and cool despite being pre-loved. It's also a great way to get unique quality pieces that are (sometimes) at a lower price point, but with the same wonderful quality.

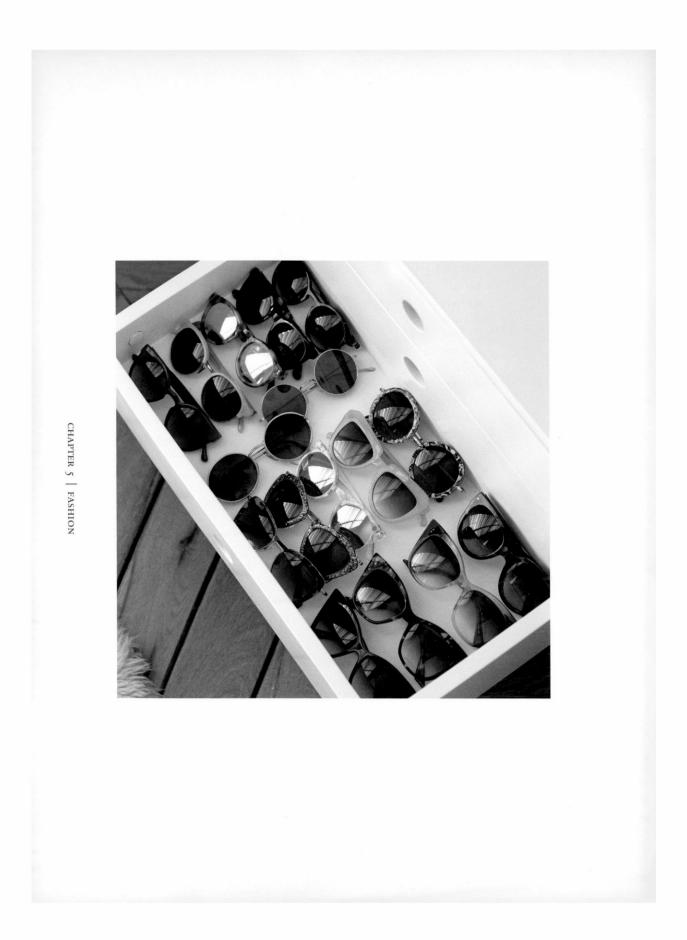

Accessories

Speaking of sunglasses, I absolutely have to talk more about them. They are most definitely my weakness and I have spent years collecting my favourites. I think I love sunglasses so much because they can completely transform an outfit and, in general, they're just a badass thing to wear. Sometimes I don't like letting other people see my eyes (like early in the morning or when I'm in a bad mood). It's also a really easy way to incorporate unique colours and shapes into your outfit. Eyewear is so personal and it's one of my biggest dreams to have my own sunglasses range one day.

I also have a huge love for jewellery, scarves and other accessories. I almost always head straight for the accessories aisle when I'm shopping, but I try to restrain myself these days. Getting compliments on my jewellery is so meaningful to me because it's something I've spent a lot of time curating. I purposely choose my rings for each individual finger and I pair them with certain bangles and earrings depending on my mood. When it comes to jewellery and accessories my motto is, 'Why be subtle?' More is more.

Loungewear + lingerie

Last, but certainly not least, is loungewear. I like to be comfortable at all times, but especially when I'm chilling at home. Although I have been known to throw all caution to the wind and wear huge granny panties with one of Aslan's T-shirts, for the most part I try to carry my style through to my loungewear. Believe it or not, having nice loungewear will actually help you relax. There is literally nothing better than getting out an evening shower and slipping into silky pyjamas: FACT. I also love joggers for everyday purposes because it allows me to feel comfortable but not look like a complete slob if the doorbell rings.

For a huge part of my life I was wearing the wrong underwear. It wasn't until a few years ago that I went on holiday with one of my best friends and she saw them sitting in my suitcase. I was a granny panty addict. I have absolutely nothing against briefs, but my underwear was next level huge. They genuinely went up past my belly button and she had to sit me down and gently tell me that I was a VPL (visible panty line) victim. It was a dark time. How did I not know this? So we went shopping and she showed me her favourite lacy thongs. I was like 'HELL NO, am I going to feel comfortable with a piece of fabric lodged between my cheeks?', but here I am today … I am a thong wearer. Thongs aren't for everybody, but my point is that underwear and bras are things we wear every single day (unless you like to go commando?) so it's important to have things that make you feel sexy! Go through your underwear drawer right now and ask yourself if that piece of underwear represents you. Mine certainly did not, but they do now.

Six
—
Home

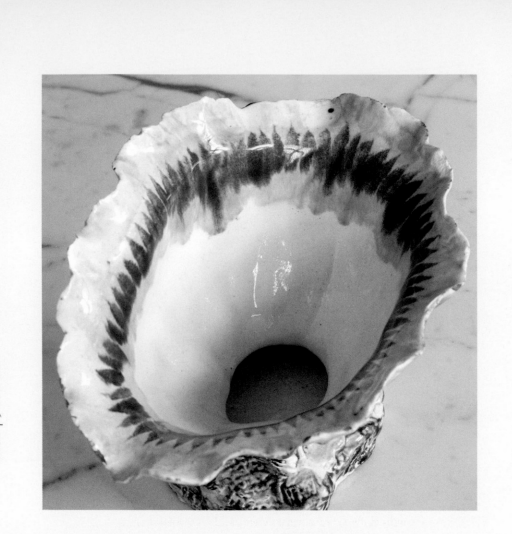

I love being at home, I always have.
I love having my own space just the way
I like it, I love organising things the way
that makes sense to me, I love being
surrounded by things I love and I love
feeling comfortable.

Being at home makes me feel safe, it's my cocoon. After all, I am a Leo and that means that I will do anything to protect my kingdom!

When I was growing up and trying to figure out what I wanted to do with my life career-wise, I considered something to do with interior design or decorating. I absolutely love watching home improvement/makeover shows and, when I was 19, I enrolled in an interior design course at my local college. I always get this feeling in my gut when something doesn't feel right and unfortunately I started to feel that ominous feeling. It wasn't the career for me because I have my own interiors style and I'm not very good at listening to a client's preferences! Thankfully, I realized sooner rather than later that I wouldn't make a very pleasant designer to work with. I left the course and decided to carry on with interiors as more of a passion project.

I realized recently that I've never truly had a space of my own. I went straight from living with my mom to moving in with Aslan, so I've always felt like I needed to share space with other people and compromise on my interior vision to allow everyone to be happy. Aslan and I have similar styles and they have grown together over the years, but they're certainly not exactly the same. For example, I love adding in a few thrifted knick-knacks into a modern space to make it feel more eclectic, but Aslan usually finds my discoveries weird and a bit offensive to his streamlined taste.

One of my favourite objects is a white porcelain cat with eyes that seem to follow you around the room. We named it the Creep Cat (although I don't find it creepy) and after years of having it in our living room Aslan banished it to my office. He couldn't stand to look at it for one more day, which is a shame because I think it's glorious. I got my revenge when I bought a vintage Italian sculpture that looks like a vagina. It now proudly sits where the cat used to live. Who's laughing now? Muahaha.

When I moved to England, I had two large suitcases (mostly clothes). Two suitcases is not a lot. Imagine fitting your entire life into two suitcases? For those of you that are thinking 'easy!' then I salute you for living that

minimalist lifestyle. I had to really narrow down my possessions and be quite harsh with the things I had to say goodbye to. That jacket I only wore a few times? Sorry, sister, you're staying in Canada!

Our first place in Cambridge was furnished when we rented it, so it came with lots of ugly furniture that, for whatever reason, I adored. Sometimes I miss the white-and-gold-framed bed, although it was strange at first to sleep on a mattress that wasn't my own.

Our bathroom had bright blue carpet, which absolutely repulsed me. If there's one thing I will stand by it's that carpet around a toilet should be banished, particularly in rentals. Can you imagine what was lurking down there in its tired fibres? Can somebody please make this illegal?

After that we moved into a shared house with a communal living room and kitchen. We had a rather gigantic bed (it was a super king!) and our own bathroom. This was the first time I had lived with other people and it felt strange. I couldn't walk around in my underwear, I couldn't fill the fridge with just the food I liked and, worst of all, I felt like I had to wait until everyone went out to poop in peace! I can't poop under pressure, but perhaps this is a story for another segment of the book. Anyway, it was a great experience because I learned that I need my own space. I didn't care if I had to live in the tiniest flat England had to offer, as long as it was just Aslan and me.

We rented our first unfurnished flat in London. This was the first time we had a totally blank space to work with. You learn a lot about your partner when you're moving in together and I was certainly learning a lot about Aslan. We would spend hours flipping through design books, scrolling through the endless design blogs and eventually created a long list of items we needed to buy for the flat. Ikea was a great place to start

for us because they have modern, simple designs
at a reasonable price.

On our first trip to Ikea I called Aslan a 'selfish
asshole' and he told me go get lost in the kitchen section.
This was all over a coffee table, I might add. Now
whenever I see people arguing in Ikea it makes me feel
nice inside. Since then I've learned to pick my battles
when it comes to most things, and especially furniture.

At the time we moved into our first flat together,
we were both really into mid-century modern furniture
and fixtures. We went to second-hand markets every single
weekend, and were so obsessed with getting bargains that
we never left empty-handed. In fact, these markets and
car boot sales are where I purchased Creep Cat for £5.00.
We used to wake up every single Sunday at 5:30 or 6 in
the morning to catch the early bird special. We found it
exhilarating, and I always looked forward to a hot cup of
tea and a bacon bap once we got inside the market entrance.

One day we found a gorgeous sunburst clock and
loved it so much that we kept buying them until we had
about six in our flat. We arranged all of our sunbursts
on a single wall but I don't think we ever got around
to setting the times properly.

**We didn't have much space in that flat, but we
did the best with what resources we had. Our style
has definitely grown together since then, but I will
always love our first real flat together.**

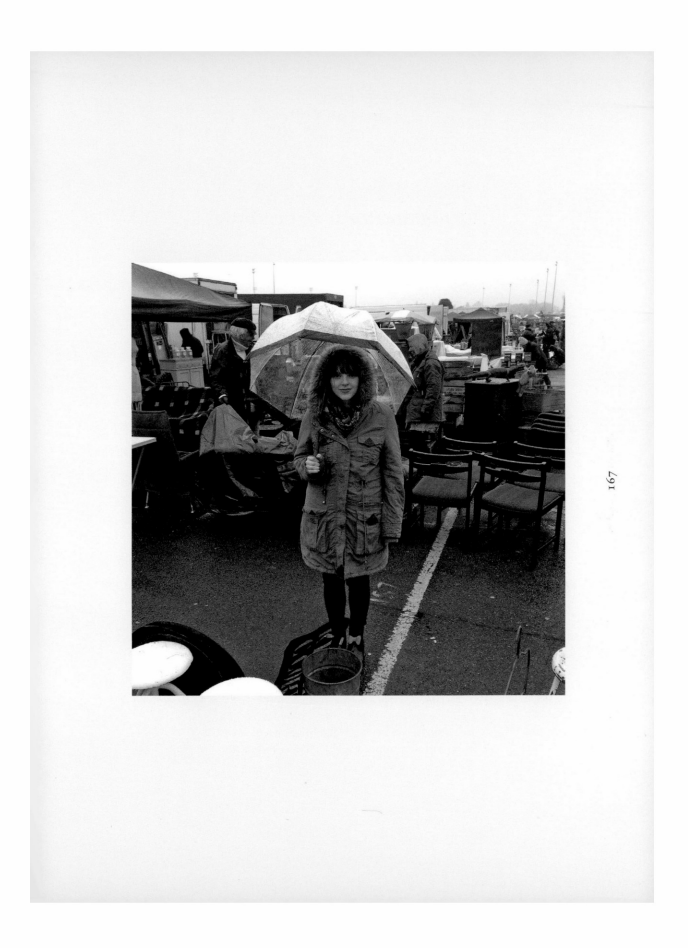

Furnishing your first home

1. From furnishing our first flat, I learned not to focus too hard on one trend. We were so narrow-minded when it came to the types of things we looked at for our home. In the end, it made our place look a bit staged and too 'on purpose'. Now I look at interiors in the same way I look at beauty and fashion. I don't want it to look like I've tried too hard to pull it all together. It's important to find your home's identity, but I would recommend approaching it from a more organic and eclectic place. If you love it, get it, and it will more than likely all fall into place.

2. I love spaces that are filled with unique objects, pops of colour and loads of different fabrics. To me, anyone can have a minimalist-looking home, but what makes it a great space are all of those personal touches that individualize the space.

3. I try to remember when it comes to styling my home that it's the same as a wardrobe. There are certain investment items and there are other things that you might want to refresh every now and then so you can save some money. Chairs and couches are important investment pieces because you will be using them daily and for long periods at a time (if you're anything like us). When you live in a small space, they form the heart of your home. In our current living room we have a gigantic grey couch, which we'll have for years to come. Unfortunately, one of my bright purple pens exploded on the couch, which I tried to hide with a pillow unsuccessfully.

4. We also have a pink day bed! Can you tell who made
 the decision to get the daybed in a lovely pink fabric?
 I love a white, grey and neutral colour scheme, but
 a bright colour really lifts our living room while not
 stealing all of the attention away. It's one of my favourite
 pieces in our home because it keeps the energy flowing
 throughout the space and adds a bit of life. I love simple
 lines and minimalist pieces paired with bold accessories
 to warm up the space and make it feel comfortable.
 So don't be afraid to try a few bold colours (step out
 of that comfort zone) or features to bring personality
 to your home.

5. I think it's also important to remember that your home
 is always evolving. I enjoy taking risks when it comes
 to interiors because it does not have to last for ever!
 Although, I swear my grandparents have had the same
 curtains for about 20 years. If you like something, keep
 it. If you feel like switching it up, you can. Practice makes
 perfect, but the best thing about interiors is that they're
 never perfect. They're like a living, breathing object. Your
 home needs constant love, energizing and refreshing.

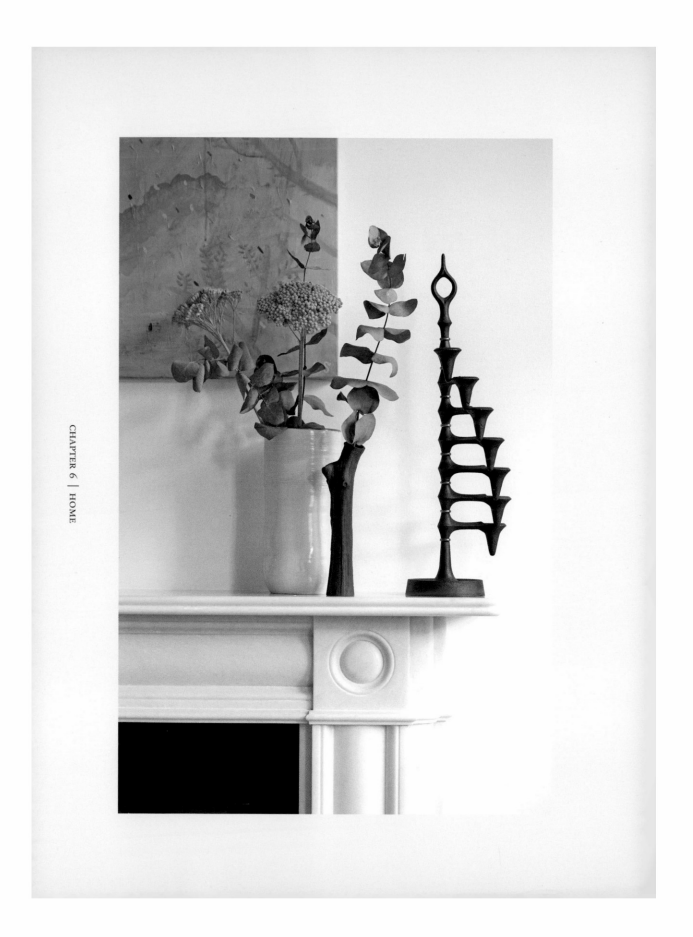

The psychology of colour

Colour psychology is widely used in marketing and branding campaigns because it can influence a customer's mood so much. Crazy, huh?

Speaking of colour, I want to take this opportunity to tell you all that I've had three separate psychics at different times tell me that my aura is a rainbow. Apparently this is very rare (yes, I'm bragging about my aura) and it means that my energy is pure and that I am a natural healer. I love reading about auras because whether you believe in it or not, they are an interesting take on what different colours represent. Anyway, I'm a firm believer that different colours have the ability to enhance our moods and this is not something to ignore when decorating a space.

Would you rather spend an afternoon in a light and airy room or a dark space with no colour? Everyone is attracted to different colours and the more you tune into it, the easier you'll find it is to pick out colours that make you feel the best. Don't just pop into the hardware store and pick a colour at random! Really think about your colour scheme. Colours bring their own personality traits to a room and we all interact with colours differently, which is why it's so important to take your time when choosing colours for a space. What do you want to feel when you're in a certain room? One of my favourite colours is green because it represents balance and refreshment. I bring green into my space through the photographs we have hanging on the walls, as well as with my plants, of course.

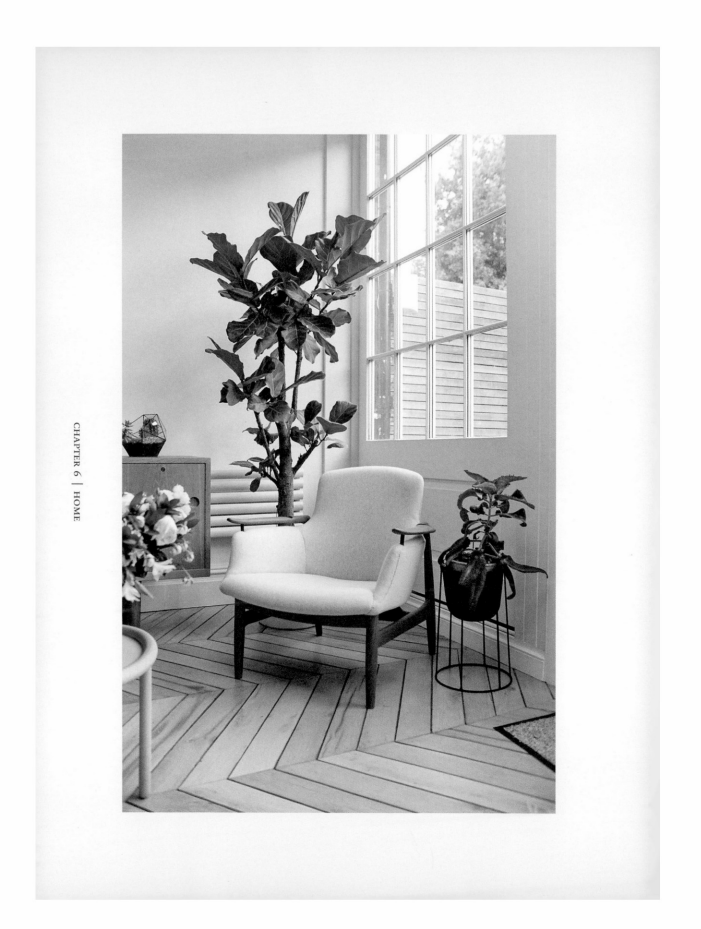

Bringing nature inside

Have you ever wondered why being in the middle of a
forest or by the water feels so relaxing? It's because of the
energy, man! Nature is so special and we need it to survive.
Bringing nature inside your house makes it feel homely,
in my opinion. If I go into someone's space and I don't
see a living plant in sight it makes me go crazy. Recently,
I stuffed one of my gigantic trees in my tiny little car and
forced it upon one of my friends. At first I think he thought
it was a just a beautiful object, but now he understands
the positive effects it has on his creativity, his general
mood and the overall feeling of his space. Walking into
a room with plants and flowers is like having ice cream
with your slice of pie. Who says no to ice cream?

I do wonder where the idea of giving someone you love flowers came from. Giving flowers and plants to people is one of my favourite gifts to give. Of course, flowers are only temporary, but for the week they're sitting on someone's desk or coffee table, it's a reminder to that person that someone appreciates them. Plants, on the other hand, are the gift that keeps on giving. They give life, texture and depth to a space, which is why you should put them everywhere you can.

Certainly for as long as I can remember, my mom has been the proud owner of a *Dieffenbachia* plant. This plant is so humungous that when my brother and I were little we thought it was a beanstalk. As in the beanstalk Jack climbs up. Apparently, my mom moved house one January (which is very cold and snowy in Canada) and her brother dragged the tree by the base through a snow-filled parking lot and it still survived. Whenever it got too tall (sometimes it was taller than the ceiling) my mom would take a huge butcher knife, cut the top off and give it to one of her friends. I guess I just figured out where my plant-gifting passion came from!

I love flowers of all descriptions. In my opinion it's the best way to add colour and brightness to a space because they truly lift the mood of a room. I love treating myself to a little bunch of flowers when I'm picking up my groceries. They don't have to be the most extravagant or expensive flowers; as long as you love them they will bring you joy.

One of my all-time favourite ways to spend the weekend is to go to a flower market. There is something so simple and special about choosing your bunch and heading home with them carefully in your arms. Flowers and plants give me a natural high, which is why I have so many of them.

Crystal power

My love for crystals started when I was about seven years old when I started collecting tiny little stones. I was obsessed with becoming an archaeologist and discovering rare fossils and stones. Obviously my career didn't quite go in that direction, but I have since reconnected with that passion. I have a new mini crystal collection now.

At first I thought the idea of crystals having healing effects was absolutely insane but the more research I did, the more of a believer I became of the positive effects of crystals.

I know I sound nuts, but I don't care. Some of the most successful and inspirational people I know believe in crystals so I'm going to stick with it. I've converted some of my most sceptical friends into believers (I swear this book isn't one big subconscious ploy to get you to join a crystal cult or something).

Aslan is the most sceptical person you will ever meet, but even he respects my love for crystals. He was actually the person who got my adult crystal collection started! For our anniversary, he surprised me with two beautiful quartz crystals, which will always be my favourites. Shhh – don't tell the others!

I'm not that knowledgeable about how crystals work, but I do know that crystal healing is an ancient art that works through the vibrations of crystals. Everything is vibrating at all times (for instance your

brain, your heart and your emotions) and depending on the
crystal – the country it's from, the weather conditions, the
molecules it's made up of and each individual's response to
a crystal – it can have different effects on a person. Some are
better at helping you sleep, some help you clear your head,
some help with depression and the list goes on. I have no
idea if they really do work, but they're beautiful and I find
they have a similar positive effect on me as plants do. My
dream is to have a bathtub made entirely of quartz (imagine
the relaxing energy of that!) but I don't think I'll be able
to afford that unless this book reaches *Harry Potter* status.
Who knows, maybe one day? A girl can dream.

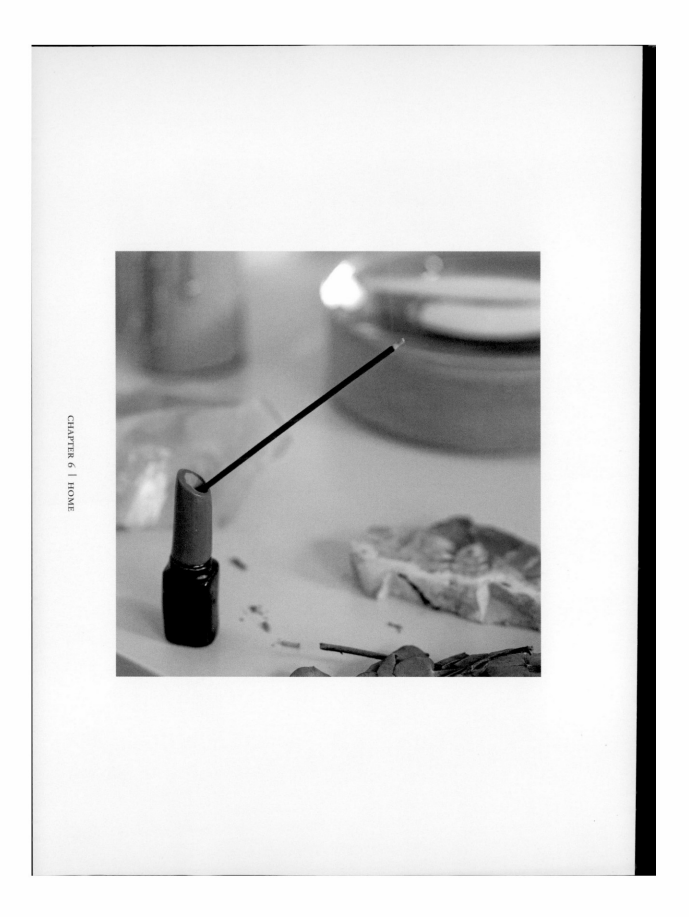

CHAPTER 6 | HOME

Candles and incense

Scent is another key part of creating a complete space. Fragrance is such a powerful sensation as it can evoke strong emotional reactions and associations – think of how a perfume can bring back some of your strongest memories. Fragrance can create a chilled-out and calm atmosphere; it can lift you up and energize you.

Candles are an easy way to get fragrance running through your home, but I also love incense. On a recent trip to New York, I walked into a random shop that smelled absolutely out of this world. Something came over me and I had to borderline threaten the shop assistant to tell me the brand and name of the incense he was using – it was by Kuumba. Now, every time I burn it in my home I think of that wonderful trip to New York. I love watching the flame of candles or the tiny spiral of smoke from the tip of the incense. I've also been testing out an alarm clock that wakes you up by activating essential oils that will scent your space. It's like waking up to the smell of bacon on a Saturday morning … except in this case it's lavender and rosemary.

Home comforts

I need to have a house that people walk into and instantly feel comfortable in. That's something I always admired about my mom's house growing up and I hope I'm doing a similar thing. My mom always let our friends come over, and always let us chill out in the kitchen and make a giant mess; our house was always the hub for our friends. In fact, we usually just left the front door unlocked (it's Canada, people) and our friends would just walk in uninvited. It was pretty wonderful and whenever I go home to visit my family it makes me feel so happy when one of my brother's friends walks through the door and says, 'Anybody home?'

Summer barbecues, late-night nachos and movie nights all go down at my mom's house, which made my upbringing so fun. Talking to my mom about this now, she says she always wanted to have a home where people could feel free to be themselves and she has definitely achieved that.

Both my brother and I had friends in need of a roof over their heads, so the spare room became theirs, no questions asked. I have officially adopted my mom's famous phrase, 'This is a self-serve zone! If you want a something, get it yourself!' *Mi casa es tu casa*.

Your home is a reflection of yourself

Just as clothing, make-up and taste in music reflect who you are, your home does as well. I'm all about having things in your space that make you feel something. We take pottery classes occasionally and I love scattering our creations around the house because it adds a real personal touch. Besides that, I try to keep things as organized as possible. If your space is chaotic, you will feel chaotic.

That's not to say my house never gets messy because at the moment the amount of clothes on my bedroom floor is alarming; it's genuinely a fire hazard at this point. Because of this, I feel very distracted and it's another thing I need to add to my never-ending to-do list.

'Clear space, clear mind' is true. Whoever invented that phrase is a genius and I wish I could stick to it. The craziest thing about having an organized space is that it doesn't actually take that long to organize your house once you get into it. However, it's one of those daunting tasks that everyone likes to put off and put off until the point of no return. At that point it might take a few hours to get everything organized, so I always aim to clean up as I go.

Instead of throwing my jeans on the floor, I should take them off and put them in their drawer right away. I'm pretty good at doing this, but one slip-up at the end of a long day leads to another one the next morning, which leads to disastrous messes like the one I'm dealing with right now. It drives me insane. If my kitchen is a mess or my bedroom is untidy I can't get anything done. I make the time to clean up my space as much as possible before I get to work.

My teenage self would never believe that I find cleaning stress-relieving. If I'm annoyed or feeling stressed my instant solution is to go to my office and organize all of my papers, drawers and bookshelves. I love putting some music or a TV show on and getting things organized! After about 20 minutes of doing that I feel much calmer, more relaxed and my mind feels clear. I'm the type of person who can't go on a holiday unless my bed is made.

Cleaning is a form of therapy and meditation for me. If you hate spending time organising and cleaning, try looking at it from a different point of view. Imagine this as your time to think about things, be alone with yourself and feel calm. It might change the way you experience it.

Creating your at-home sanctuary

Everyone needs a space they can call his or her own, and that space is different for everyone. It used to be my bedroom, which I had decorated myself in lavender damask print wallpaper (barf) and *The Breakfast Club* posters.

My teenage bedroom was so tiny and it had just one little window in the corner the size of a laptop. It was a space that was just mine. I could close the door, light my nag champa incense and listen to Led Zeppelin all I wanted. For years that was my at-home sanctuary. Now, my sanctuary is my office. It's filled with all of my beauty products, pictures of my friends, my favourite books, my candles – it's all there.

I also love my bathroom because, although I share it with Aslan, it has a lock on it. When the door is locked, it's my space. My space to do a one-hour facial, my space to take a bath and my space to be alone! It's also possible to have 'sanctuaries' outside of your home, such as a favourite café or a favourite park bench. Those spaces are important to me too, but the spaces at home are so much more personal and I need them to stay balanced.

It's hard for me to narrow down my favourite pieces in our home, but here are three things that represent different aspects of our home.

Glass vase

What's nice about this vase is that it's a one off. It's something that is very unique because of its organic and imperfect shape. I stumbled upon this inside a tiny little store in London that specializes in Japanese products and the lady who runs it told me that it was hand blown by an artist who makes very small batches of his work at a time. I fell in love with it and it is now my most used and favourite vase.

Bedside tables

If you're wondering where we bought these I'm afraid you're out of luck because the one and only Aslan designed them and had them made specially for our home. We could not find the perfect side tables for our space so he took matters into his own hands and sketched up some ideas. After a few months and getting in contact with a carpenter, voila! We love them!

Wishbone chairs

Sometimes you have to turn to an expert and there is no greater furniture expert than Hans Wegner. He has made thousands of beautiful chairs that have stood the test of time and, for me, the wishbone chair is one of his most beautiful and by far his most practical. It's curvy yet robust, looks great from every angle and just feels rock solid.

Seven

—

Travel

When I was a little girl, I was fascinated
by all of my mom's travels. She used
to be quite the jetsetter, as part of her
job meant going to places like Singapore,
Ireland, Mexico and many more.

She once went on a week-long trip when I was around eight years old, so it felt like three lifetimes. On the day she returned, my brother and I waited patiently by the door and before she had even sat down she was already opening her suitcase to show us chocolate brands we'd never seen and miniature cans of pop from the airplane, which blew my mind. 'Sheep are everywhere in Scotland,' my mom told us, as she handed us a stuffed animal sheep, which has since been passed down to our family dog.

My eyes were glued to the TV whenever it showed a country I had never seen before. I was so intrigued by people who spoke different languages and ate food I had never heard of before. Keep in mind that growing up in suburban Canada, I wasn't exposed to much diversity and most people I knew didn't have the kind of incomes that allowed for travel. Seeing the world was important to me. I didn't know how I was going to do it, but I knew it was something I needed to do. I would speak to anyone I could about the places they had been and, if it seemed interesting, I would add it to my ever-growing list of places to see before I died.

Although I am definitely a homebody, I love going to new places. Travelling is important because it allows you to encounter things you wouldn't have otherwise experienced.

It allows you to be spontaneous and energized in new surroundings, all the while learning about a different culture. It's such a unique feeling when something you studied at school or a place you've always wanted to see is right in front of you. Seeing these things gives me a sense of accomplishment and I can mentally check it off my list like, 'Seen that, now what!?'

I think travelling is the best way to keep in touch with those childhood feelings of wonder and curiosity. There is so much information to absorb in this world and travelling is like an immersive crash course. No matter where you go,

I can guarantee you'll learn something new. I think for me the most special part about going away is realizing that your problems and struggles seem huge in your own personal world, but when you go to other places you see so many other people with their own issues, their own families, their own ups and downs, and it gives you perspective. It reminds me that we are all the same despite differences in culture, traditions and ways of life. I know that I've become a much more open and accepting person since seeing first-hand how other cultures behave and why that works for those countries.

If everyone travelled there would be much less hate in this world because it's difficult to hate something you understand.

I love meeting new people and hearing about their experiences and their outlooks on life. Besides that, travelling with the people you love is such an incredible bonding experience. Aslan and I have seen so much of the world together and grown together because of it. All of these experiences are sewn into my soul like a patchwork quilt. I hope I'm always healthy enough to travel and see the greatness of the world.

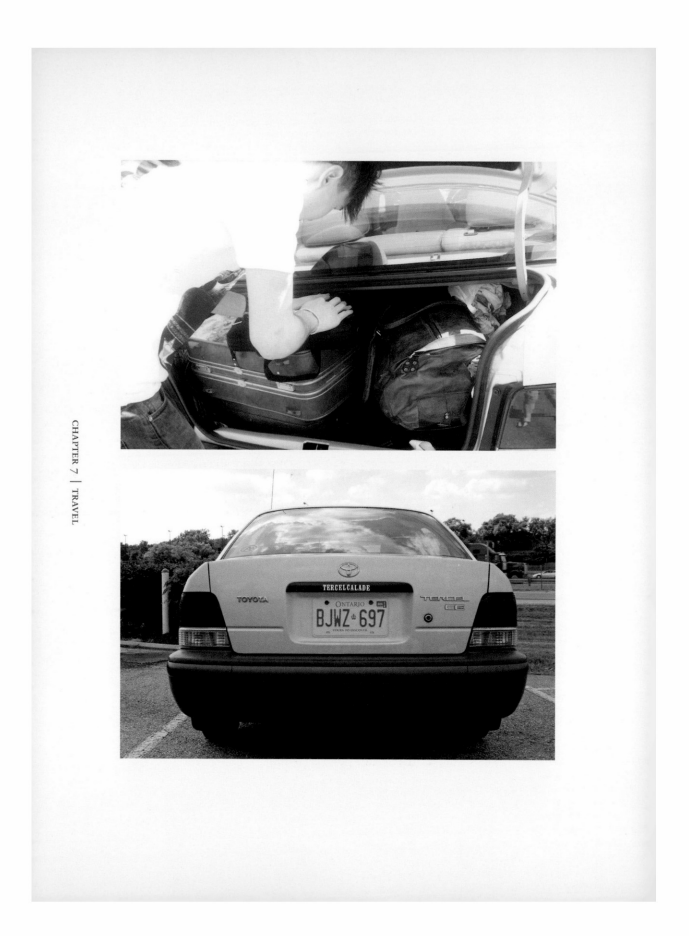

North America

Before making the big decision to move to England, I hadn't done much travelling. I had been to New York City for a week when I was 15, Dominican Republic when I was 14 (my first time on a plane), Michigan to go shopping at American stores a few times as a kid, and the west coast of Canada for a week when I was 17. That was pretty much it, but it was getting harder and harder to ignore my travel bug.

The dream for me when high school ended was to pack a bag and just go. I used to repeatedly write the phrase 'anywhere but here' on my notebooks, so I jumped at the chance to go on a new adventure across America with Aslan when we were just 19. We both worked hard to save up for the trip, so packing the final suitcase into the back of our car and slamming the trunk was exhilarating. My mom was at work the day we left, so we swung by her office and I said goodbye to her for seven weeks (she cried).

We pulled out of the parking lot, blasted some music and screamed for joy ... I WAS FREE! Free from feeling suffocated in my small town, free from running into people I went to school with wherever I went, free from being supervised and free to be whoever I wanted to be. I was leaving on my own terms and I did not look back.

The feeling I had for those seven weeks will never be forgotten. I was 19, had zero responsibilities, I was in love and I wasn't cynical enough to worry about the bad stuff. Those seven weeks are the closest I have ever come to floating and I will probably never stop chasing that high. I stayed up all night long, wandering around unknown cities. I felt invincible, lucky and in control.

We saw whales in Maine, ate the best peaches I have ever had in Georgia, had our fortunes told in New Orleans, held baby alligators in Louisiana and felt the searing heat of the sun in Texas. Our wonderful shitbox of a car had no air-conditioning (it was so hottttt!!!) and no CD player, so we managed to find some cassette tapes at a garage sale somewhere along the way.

Our road trip playlist was the *Best of Patti LaBelle* and other soul singers, which always made us feel the funk, even in the hottest heat. Sometimes I still play those songs in the car and it takes us right back to being kids again.

This was the trip that made me fall in love with travelling. Those experiences fed my soul in ways I didn't know were possible and I will have the memories for ever.

NEW YORK CITY, NEW YORK

New York is a city that I have always loved, but it wasn't until recently that I could actually see myself spending a lot more time there. There is no place like New York and it really is the city that never sleeps. New Yorkers hold nothing back and I admire their boldness. The fashion in New York is my absolute favourite. Brilliant city, I'd love to live there for a year or two.

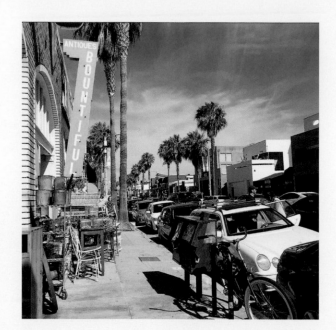

LOS ANGELES, CALIFORNIA

The first time I went to LA, I felt like I was dreaming.
It's a place you hear so much about and see so often in the
backgrounds of films and TV shows, but actually spending
time in LA is a completely different feeling. It's very spread
out and laid back, yet you get a sense from everyone
around you that no one is joking around. People are in
LA to succeed and have a great time doing it. It's a magical
place where anything can be created and 'no' is never the
answer. I adore visiting LA.

AUSTIN, TEXAS

Austin is a little liberal town in the middle of conservative
Texas. The vibe is very creative and is a nice mix between
tech start-ups and old money. There are loads of creative
people, cacti, starving artists, delicious food, great live music
and, of course, it's the home to the Magnolia Café, which
is open '24/8'. As the Austinites say: Keep Austin Weird.

India

India is exceptional. I'd read books and watched documentaries in preparation of our trip, but nothing can explain the feeling you get when you touch down in Delhi. The air is thick and hot and it smells like incense. It hits you like a physical object and swirls around your head until you remember that you're not dreaming. Being in India is like being in a constant trance. When it's good, it's great and when it's bad, it's really bad. I got terrible food poisoning (or Delhi belly) on the fourth day into our trip, but that didn't stop me from going on a two-day camel excursion into the scorching desert.

Camels are beautiful creatures and this trip was the first time I'd seen one up close. I was in awe of their long, luscious eyelashes and their kind eyes. Once I managed to get on top of the camel, I thought I was going to die of food poisoning. We trotted further and further into the sand dunes and, after six hours, we were finally at base camp. I jumped off the camel as fast as I could and headed for the nearest bush. I had to accept that the entire tour group would see and hear me shitting and barfing my brains out. I've never felt so sexy … not.

I was definitely more in tune with my body after that experience and my phobia of pooping in public was cured on this excursion. Silver linings, people. I was so busy relieving myself that I didn't even notice the thousands of gigantic black beetles that crawled all over the sand. I have never been so terrified in all my life – these things were everywhere and they leave little claw marks in the sand. If someone told me beforehand that these little creatures would surround us, there is no way I would have gone, which is probably why the tour guides didn't mention it to anyone.

In contrast to the paralyzing heat during the day, the desert was absolutely freezing at night. I brought one light jumper and they provided us with a blanket full of holes. I have never been so cold in my entire life: my nose was like a faucet and my entire body was shivering uncontrollably! But in the end none of that stuff mattered because I was in the middle of the Indian desert staring up at the starry sky taking it all in.

CHAPTER 7 | TRAVEL

Scandinavia

Another one of my life-changing trips was a three-week road trip across Scandinavia, known to my viewers as the #NordicVlogs. As you can see, we really love road trips. There is nothing like hitting the open road and watching the world go past you. We started out by driving from London to Dover and taking the ferry to Calais. I have severe motion sickness and this would be the first of seven boat rides we would take on this trip, so again I lost all of my dignity and threw up several times in front of large crowds. I've come to terms with this inconvenient little issue of mine, but it sucks.

AARHUS, DENMARK

From France we drove through Germany and on to Aarhus in Denmark. If I ever decided to move to Denmark, Aarhus would be the place for me. It's a tiny town with such a positive atmosphere. Scandinavian culture fascinates me because they put real emphasis on human relationships and being social. We stayed in some absolutely stunning apartments on this trip, which gave us major home-decor envy. Aarhus, in particular, is filled with creative people who take the time to chat and they have a serious passion for coffee. Aarhus also fuelled my gourmet hotdog addiction (I think I ate one every day we were there). In general, I felt calm, welcome and peaceful when we were in Aarhus and I didn't want to leave, but the rest of Scandinavia called!

There is also a place in Denmark called Skagen, which was my favourite stop on our three-week journey. The town itself was very quiet during the time we went and it almost felt like a ghost town. I was exhausted the day we arrived from days of travelling, but Aslan (the man has a never-ending supply of energy) convinced me to go for a walk in the sand dunes. I didn't really understand what made these sand dunes so special, but as we walked further and further away from the car we were greeted by hundreds of gigantic sand mountains! Something came over both of us and we simultaneously ditched our shoes and started running. Something changed for me in those moments: I felt like a little kid again despite being absolutely exhausted just minutes before. If you ever get a chance to run down a sand dune in bare feet, you absolutely must do it. It's the closest I've ever come to flying.

After a couple hours of that we took a break on the edge of one of the dunes and soaked up our surroundings, and I forced Aslan to take a selfie. Just when I thought Skagen couldn't get better, the next day we had a leisurely breakfast and then headed for the sea! At the edge of Denmark there is a point where two different seas meet and people come from all over the world to see it. Everyone on the beach was heading straight for the shoreline. We were among a group of about 150 people who had all travelled to see this particular point in the water; it felt like a movement ... we were all part of something. When we got to the water I could see the two seas clashing against each other from opposite directions. Again, my childish instincts came over me and I ran in with all of my clothes on. The water was freezing but it was well worth it. I can now say that I've stood in two seas at the same time, which is pretty cool. And, in case you're wondering, it did feel magical. That's not your average seawater. Go. Stand in it. FEEL ALIVE IN IT!

Driving through the out-of-this-world mountain scenery in Norway is something very special. I wanted to stop the car every five minutes just to take a picture, but the more I looked at the pictures, the more I realized they could never do it justice. The air was so crisp and fresh in Norway, and the higher we got, the colder the breeze. It felt like we were driving for ever and ever. There was one point I even thought we were going to drive off the edge of the world – it was scary and fun at the same time. Luckily for me, the world is not flat and I'm still alive to tell you about the spectacular views of Norway.

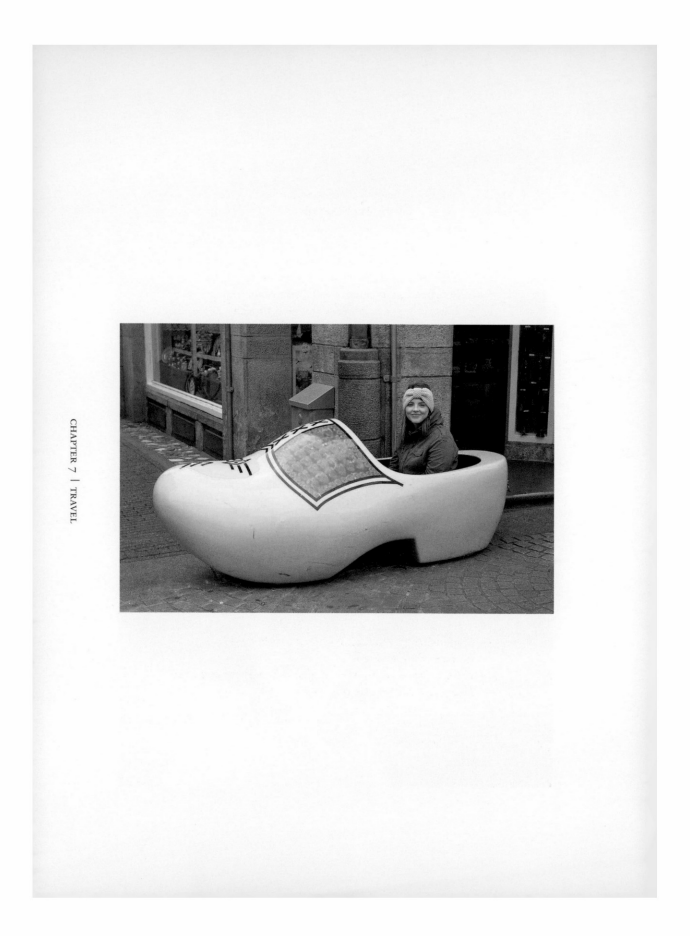

Europe

Since I live in England now, it's a lot more convenient
to go away for city breaks, which basically means
a mini-vacation to see another city. I love travelling in
Europe because it still feels like a faraway place for me
and every country has its own identity. Growing up in
Canada, I always felt like I would never get to see European
countries and, in fact, I cried the first time I saw the Eiffel
Tower. When I look back on all of the amazing places
I have been to I get so emotional – it means the world
to me. I've mentioned that I always dreamed of travelling,
but to actually live a life where it has happened is so
extraordinary. I feel so lucky and humbled that I've had
these wonderful experiences, and I never take them for
granted. There are so many more places I want to see
in Europe, but here are some of my favourite memories.

AMSTERDAM

— Visiting the Anne Frank House and feeling the weight
 of the environment
— Eating Vlaamse frites with mayonnaise and peanut sauce
— Going to a coffee shop (just saying …)

FRANCE

— Browsing inside the first ever Chanel store
— Wandering around the Palace of Versailles pretending
 to be Marie Antoinette
— Spending hours in the line to go to the top of the
 Eiffel Tower was worth it for that view
— People watching all of the stylish Parisian babes

ITALY

— I'm not a religious woman, but seeing the Vatican
 was a religious experience
— The gelato! And the pasta! And the pizza!
— Of course I made a wish in the Trevi Fountain

SCOTLAND

— Fight me on this all you want, but the Loch Ness
 monster is real and I saw the lake it lives in, Loch Ness
— Glen Coe is arguably one of the most stunning places
 I've ever been. Apparently they even filmed some
 of *Harry Potter* there!
— Speaking of *Harry Potter*, we went to the same café JK
 Rowling sat in as she wrote the first *Harry Potter* book.
 Outside the window is the castle that inspired Hogwarts

BERLIN

— I rode a Segway for the first (and hopefully last) time.
 Touring the city on those things was both efficient
 and hilarious
— I think Berlin is the most laid-back city in the world.
 Everyone is so chilled out and relaxed
— It's amazing to see a city so progressive in regards to
 veganism. Everywhere you turn is a vegan café or shop

I have two homes

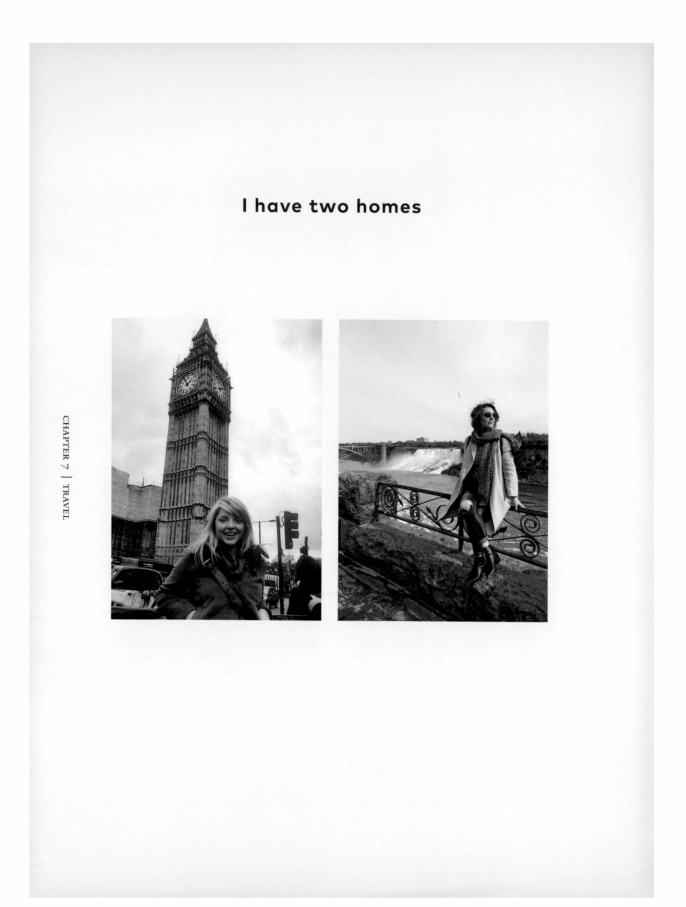

'When a person is tired of london,
they are tired of life' – Samuel Johnson

I couldn't possibly write this book without expressing
my love and gratitude towards London, my favourite city
in the world. As much as I knew I wanted to travel,
London was never, ever on my radar. I knew so many
people who adored British accents and would have died
to take a trip to London, but it never appealed to me.
Yes, I was obsessed with the Spice Girls (who wasn't?)
but that was as far as my British curiosity went.

Now that I've lived here for a decent amount of time,
I feel like I can talk about this city like it is my city. I'm not
sure how one becomes a 'Londoner' but I think I am one!
I'm a Londoner! This city has been so pivotal to my career,
my social life, my humour and, in short, it has made all
of my dreams come true. It wasn't easy – flashback to
my first Canada Day alone in London crying in the Pret
a Manger across from Trafalgar Square because I missed
home so much – but I didn't need easy. I needed the city
to slap me around a bit and test me.

I didn't know it then, but I needed this city to prepare
me for all of life's little tests, and prepare me it did. The
thing about London (or any big city, I assume) is that it's not
always nice to you. It rains a lot, the traffic can be awful,
it's bloody expensive and sometimes it will make you feel
like you're the most worthless human in the world. In
contrast, it can make you feel alive, worthy of success and
incredibly lucky to be surrounded by so much diversity.
London provides me with the streets I purposefully walk

A great day in London gives me a buzz that can
last for weeks, which definitely helps me get
through the gloomy and dark winters.

down so I'm not late for my next meeting, it provides me with restaurants to meet my friends in, it provides me with opportunities to improve myself and it provides me with the belief that I can always do better.

I have loved learning cockney rhyming slang from proper geezer black cab drivers and I'm even beginning to notice the difference between British accents! Sometimes I go for afternoon tea and eat scones like it's a normal thing to do. SCONES. I ACTUALLY GET TO EAT REAL SCONES! (You can see I'm still a tourist at heart.)

Things like driving past Big Ben and Buckingham Palace never get old to me. There's nothing like taking the tube with all of the other grumbly miserable Londoners when it's raining to make you feel like you are not alone in your misery. There is always, ALWAYS something to do in London. In the time I've lived here I don't think I've ever uttered the words, 'I'm bored.'

Most of all, living in London makes me feel proud of myself. I've come a long way in a short amount of time. Passionate, intelligent people who inspire me every single day surround me.

I could babble on and on about London, but I could never explain to you what makes this city so spectacular. You have to commit to London and London will commit to you. I'm so proud to call London my home.

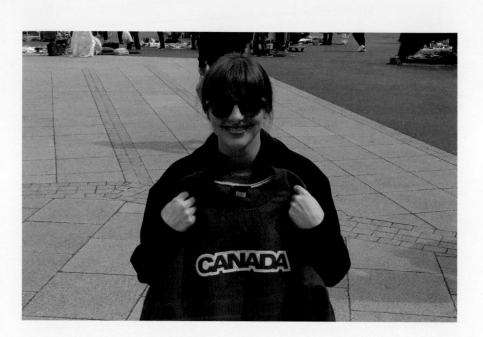

A LITTLE LOVE FOR CANADA … EH

Keep your stick on the ice!

First of all, I would like to say that being Canadian is a mindset and although I don't live in Canada, I am still very much Canadian. I have such fond memories of growing up in Canada and doing some insanely Canadian things, such as playing ice hockey on the frozen pond down the street and tapping maple trees for syrup with my dad. I thought everyone had seen snow and everyone knew what poutine was, but moving to England popped that balloon for me. I grew up in a blissful Canadian bubble (a wonderful, loveable bubble).

If I could explain what being Canadian is all about in a succinct way I would say that Canadians have an internal mantra of 'live and let live'. We just try to go about our business and, if it's not hurting anyone, we try not to complain.

Canadians like to take their time and we love to stop and smell the roses. Canada helped raise me.

My brother and I could turn a ten-minute trip to the beer store into a four-hour afternoon event. We're quite similar in the sense that we like to chat, see what's going on around us and investigate anything that seems out of the ordinary. Being Canadian (in a small town) means that, if you go into the beer store, you will definitely run into someone you know and you will most likely be invited over to their place for a barbecue. You always say yes. It means leaving your door unlocked if you're just going out for an hour or two. It means always saying hello to strangers, it means you have experienced hundreds of snow days, it means spending two hours sipping your coffee in Tim Hortons talking with your friends because that's just what you do.

We have really colourful money and our coins have amazing names like 'loonies' (one dollar coins) and 'toonies' (two dollar coins); we don't live in igloos although I've tried many times to build one with no success; we were raised to apologize for absolutely everything, which is why I'm always saying 'sorrrrryyy'; hockey is a big part of our lives and, although I have never played on a team (see soccer story on page 62 on why I don't play sports), I appreciate the game. Last, but not least, we made Drake. #6ix.

How I plan and pack
for holidays

I've had some decent experience packing for all different
types of trips and I've learned a lot about it along the way.
I've experienced forgetting my underwear and passport
way too many times for my liking, so I've devised a few
tips that help me pack as efficiently as possible.

1. Pack to mix and match your wardrobe. When it comes
 to choosing which clothes to bring I always try to make
 sure that most things go together. For example, I usually
 wear the same jeans but with a few different tops to
 give it a different look. It saves space in my suitcase
 and I don't have to pack as many outfits

2. Roll your clothes. This is such a simple and easy thing
 to do but it will save you so much space in your suitcase
 as well as reduce the amount of wrinkles in your clothes

3. Use packing cubes! These are a relatively new find
 for me but they are really useful little items because
 it keeps everything organized. Think of them like
 drawers for your suitcase. I usually have one for
 undergarments, one for tops, one for bottoms
 and one for miscellaneous items

4. I always bring an empty bag for dirty clothes and undies.
 There is nothing worse than putting a pair of dirty
 underwear on top of a clean top. Put all of the things
 that need to be washed in the bag so it's all together
 in your suitcase. It also makes it a lot easier when
 it comes to unpacking because you can just chuck
 it straight in the laundry hamper instead of sorting
 through your whole suitcase

5. Leave a bit of extra space in your suitcase in case you
 do some shopping. I know sometimes we say we won't
 do too much shopping on vacation, but there's always
 that mug or pair of shoes we can't resist. It's best
 to pack a bit lighter in case of a shopping emergency

Eight
—
Food

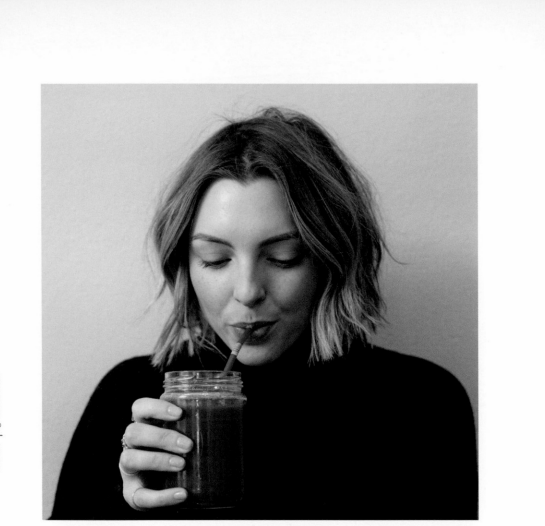

FOOD.FOOD.FOOD.FOOD.FOOD.
Food – last but not least, as I swear
it's all I think about!

Food is a very important part of my life because it's something I can share with my friends and family, and it usually involves fun times.

To me, there is nothing better than sitting down and having a delicious meal with even more delicious conversation. I love talking about my favourite foods, which evoke happy memories, and I love learning about foods from different cultures that some of my friends have grown up with. Along with all of that, eating food is also one of my favourite simple pleasures in this world. Something as easy as grabbing a plain cracker with my favourite cheese on the way out the door pleases me. I love that a hot bowl of homemade chicken noodle soup, made with love by Aslan, can make me feel so much better when I'm sick, and that sometimes a piece of chocolate is all I need to make me feel human again. Fresh watermelon on a hot summer day, my grandma's cabbage rolls (they don't sound good but they are), a hotdog on the beach, delicious olives while on vacation … I could keep going, but I will force myself to stop. What else can I say besides food tastes great and I love eating it – a lot?

Although I have always loved food, I didn't always have the best relationship with it for a long time. For a large part of my life, I used food as a comfort for any stress or problem I was having. I remember stealing snacks from the cupboard when my mom wasn't looking when I was as young as six years old and hiding chocolate in my room to eat when I was supposed to be sleeping.

I used to feel so panicked if I didn't have access to food. For instance, I used to go to my dad's house at weekends and I would always take chocolate bars in my overnight bag 'just in case'. All of this eating I was doing wasn't healthy and I was doing all of it secretly. This all started very, very young, which was when my body image issues began to develop.

I remember going to the beach for a birthday party once and thinking I looked SO FAT compared to the rest of my friends, but I couldn't control my compulsive eating habits. I couldn't figure out why I kept eating so much when I felt so bad about the way I looked. I remember feeling frustrated with myself that I couldn't get my cravings under control. I'd like to reiterate that this was an internal conversation I was having with myself at age seven, and I continued to have that conversation with myself until my early twenties. At such a young age, feeling fatter than the other girls didn't stop me from taking part in fun things like a beach outing, but I was most definitely self-conscious.

Hours were spent in front of the mirror practising how to suck in my stomach. Poor little Estée – I was thinking about dieting and I thought that was completely normal. It is so unfair that going to school and comparing bodies with other girls my age was a reality for me and is for so many other girls as well. Instead of walking home and joking around with friends, I was walking home wondering why my thighs were rubbing together or why my stomach was so huge. It was tough. And it just seemed to get tougher.

There are some evil voices inside the heads of girls that tell us that we're too fat, too skinny, not pretty enough, not cool enough, and these voices are constantly yelling inside our brains! Back then I didn't understand that these voices were telling lies and, thankfully, I'm in a place now where I've learned to silence those voices (for the most part).

That's not to say that all of my food-related struggles are over, because they're not. I've spent so much of my life thinking about food, worrying about weight gain and struggling with body image that even going to new restaurants can give me a twinge of anxiety. Will I like the food? Will the restaurant be really tiny inside? Will I be able to squeeze through the tables to my seat? I hope I can learn to silence those annoying thoughts completely one day.

I want to share my struggles with food because I think it's something that so many of us have dealt with or are currently dealing with. For me, it wasn't necessarily about my physical appearance; it was about the way I felt. I spent so much time at home on the couch not wanting to go out with friends and feeling sorry for myself. I had a lot of physical problems such as regular stomachaches, back pain and fatigue. I also had zero motivation and no energy to do things. I let these feelings consume my life for many years and I hope that sharing my insights is helpful to those of you going through the same battle.

I have self-sabotaged my success more times than I can count, but what's important to realize is that every day is a new day. There is always another chance to try again. You don't have to change everything overnight, just try to make a few little positive changes here and there. And let's try not to be so hard on ourselves.

Not eating enough

One of my most vivid food-related memories was when I stayed over at one of my friend's houses for the night. This was my first girly sleepover as a teenager (I was 13) and I was both excited to be included and nervous about what would go on. We were all hanging out in the kitchen, having candid and open chats about sex, periods, boys, etc., when one of my friends revealed that if she ever eats too much she simply just throws it up!

I knew about the seriousness of bulimia, but she said it so nonchalantly and, at the time, she was my muse. She was gorgeous, skinny and everyone thought she was perfect – I idolized her. Later, I asked her more about it and she casually grabbed my arm and led me outside to the back garden. *I was getting a lesson on how to make myself*

throw up. Looking back, I thought this was a rite of passage and I was just late to the party (like pretty much everything else in my life). She told me about her binge eating, described the process, and then taught me how to put my fingers down my throat and 'relieve' myself of the unwanted calories. I copied her habit for a week or so. Then I decided instead to eat sensibly, but to my 13-year-old self, eating sensibly meant eating very few calories per day, which I did for the duration of the year. Not even fainting at our school's football match made me worry about what I was doing to myself. I was getting hardly any nutrients, but I was getting loads of attention from boys at school for the first time, which felt amazing. I've probably never felt so simultaneously good and bad about myself at the same time.

When I entered high school, I started hanging around a different group of friends who ate whatever they wanted. Most of them seemed to have a healthy outlook on food, but I managed to suss out that a few of the girls were obsessed with losing weight. Together, we went on radical diets and compared food journals. All of these horrible diets ended with me binge eating and feeling worse than when I started.

At the time, this just seemed like part of growing up and 'becoming a woman'. We are bombarded with body-shaming imagery and advertisements about weight loss, so while I'm not surprised I was obsessed with changing my physical appearance, I look back at these moments with great sadness. I looked absolutely frickin' adorable and I was so caught up in the madness that I didn't even get a chance to enjoy it.

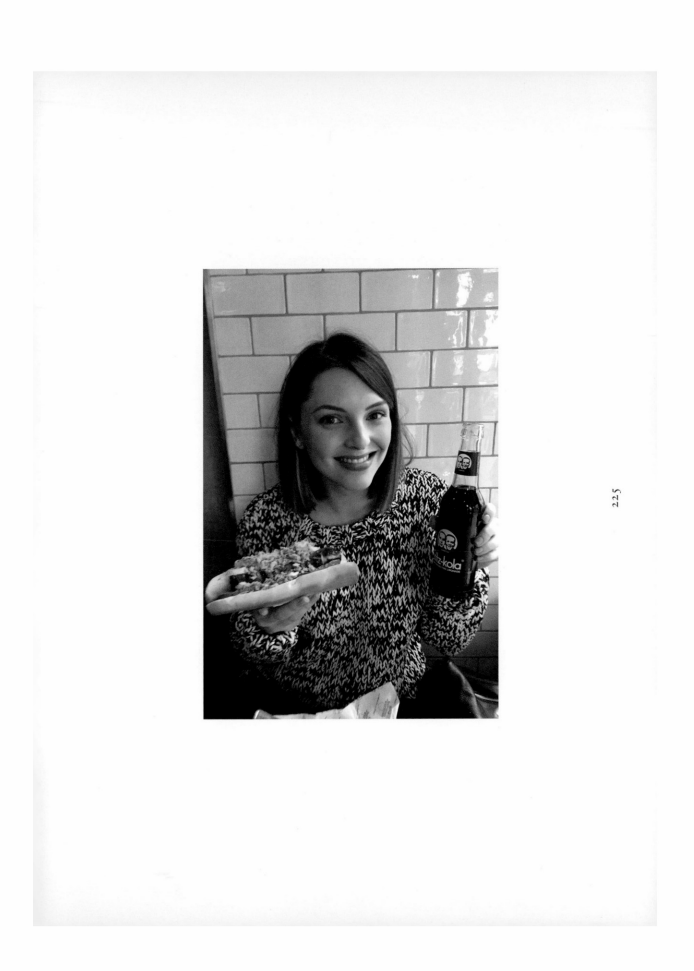

225

Eating too much +
being obsessed

Towards the end of high school and the beginning of
university, my depression and anxiety was worse than it had
ever been before. That being said, I didn't have a label for
it so I had no idea why I was feeling that way. Although
it was such a short time ago, back then mental health was
a subject I was terrified to discuss with my family or friends.

The food pendulum had once again swung in the
opposite direction and my overeating was out of control.
By this time I had gained loads of weight and could barely
fit into the largest clothing sizes at most stores. After
months of being down and eating everything in sight,
I became increasingly upset. I remember crying to my
mom that I just 'didn't feel right' and I was always sad.

Her take on it was that I needed to get more exercise,
which made me feel even worse about myself – I could
barely find the energy to go to school, let alone go for
a jog! I was stuck in a downward spiral because I knew
I was overweight and I was miserable, but I didn't have
the tools or the strength to do anything about it. Without
knowing what to do when it came to my mood, I turned
to food to help fill the empty void inside myself, which
had quite the opposite effect.

My closet eating from when I was a little kid came
right back during the end of high school and I refused
to eat in front of other people. I never brought a lunch
to school, didn't go out for dinner with friends and always
ate alone. I didn't even like eating in front of my family
because I thought everyone was judging me for what
I was consuming. 'She's so fat, why is she eating again!?'
was my most feared judgement.

When I was 19 I used to work until about 10pm and of course I wouldn't eat or drink anything in front of my fellow colleagues. I had a ritual of leaving work, going through the nearest drive-thru and ordering two of everything I was hungry for. I wanted the drive-thru worker to think I was ordering meals for two people instead of just food for myself. Sometimes I would even tell a longwinded and strange story about how my friends asked me to pick up food for them, so it seemed like those burgers weren't mine.

Those were some emotional times for me. I would sit in the parking lot, stuff my face and feel like crap afterwards. I would vow not to do it again and to get a grip, but I could not control myself. It was the only thing that got me through the day. It might seem strange to those of you who have never gone through something like that, but it was something I could look forward to and it was something I could keep all to myself.

I deeply sympathize with people who are trying to lose weight; it is not easy. Losing weight is more of an emotional battle than a physical one – something that has taken me years to fully wrap my head around.

I was in denial about my drastic weight gain for quite some time, until I saw a photo of myself alongside some of my university friends. I was at least three times the size I thought I was and I had no idea how I had got to that point. The only way I can describe the way I felt is by saying that for years I never actually looked at myself. Of course I looked in mirrors to put my make-up on or when I was doing my hair, but I was so removed from myself that I didn't notice what was going on. I was completely detached from reality until I saw that photo. Even my family and friends told me (in the nicest way possible) that I had gained some weight, but it wouldn't be until about two years later when I would finally get a grip on those emotional impulses.

It's not all bad

So there you have it. That's just the tip of the iceberg of the different types of struggles I have had with food over the years. It's not something that can be solved overnight and I have worked very hard to get to the place I am now. I have been hard on myself for so long that I greatly appreciate having a much healthier mindset now. Food exists to bring us joy, nutrients and variety. Hallelujah! Food is great! As I mentioned at the beginning of this chapter, some of my favourite memories revolve around food and I'd like to share some with you now.

1. The lamb-shaped birthday cake my grandma makes for me every single year. She has baked them for me for as long as I can remember and they taste delicious. That being said, she bakes them in bulk (about six at a time) and pops them in the freezer. Only she knows how long those lamb cakes have been at the bottom of her freezer *shudders*. It's something only a family member could love. Once the lamb-shaped cake comes out of the freezer, she covers it in white icing, sprinkles it with coconut to create a fur effect, adds two chocolate chips for eyes, a cherry as the nose and a ribbon around the neck (that's my favourite part). My grandma is so wonderful and I look forward to my lamb cake every single year! It's definitely a tradition I hope to carry on if I ever have kids of my own.

2. My mom, on the other hand, is not the best at cooking and, before you get up in arms, she will not be mad at me for saying this. She burns toast and has the local pizza delivery place on speed dial. I must give her some credit though because nothing, and I mean NOTHING, is better

than my mom's sugar cookies. It's a basic cookie recipe that has been in our family for years. I definitely became much sweeter from eating so many of those cookies on special occasions. When we were kids, my mom used to blast music through the giant speakers in the living room (mostly the Thompson Twins, Madonna and Talking Heads) and the three of us would bake cookies before bed. We had such a good time dancing around (my brother and I were usually in our underwear because it would get so hot in our kitchen). We would sing, roll out the dough and laugh our heads off. *Those were the best days*. If I could relive any childhood moments, cookie making would definitely be up there.

3. One of my favourite ways to eat is to have a little bit of everything. Aslan and I love going to markets or to a specialty grocery store to pick out a few artisanal items. Part of the fun of this type of meal is actually going out to find exactly what you're in the mood for. My favourite lunches usually consist of some crackers, a delicious cheese, olives, pomegranate seeds, hummus, rice, a selection of cured meats and some fresh pressed juice. It's so nice to have a buffet-style lunch with flavourful and quality ingredients.

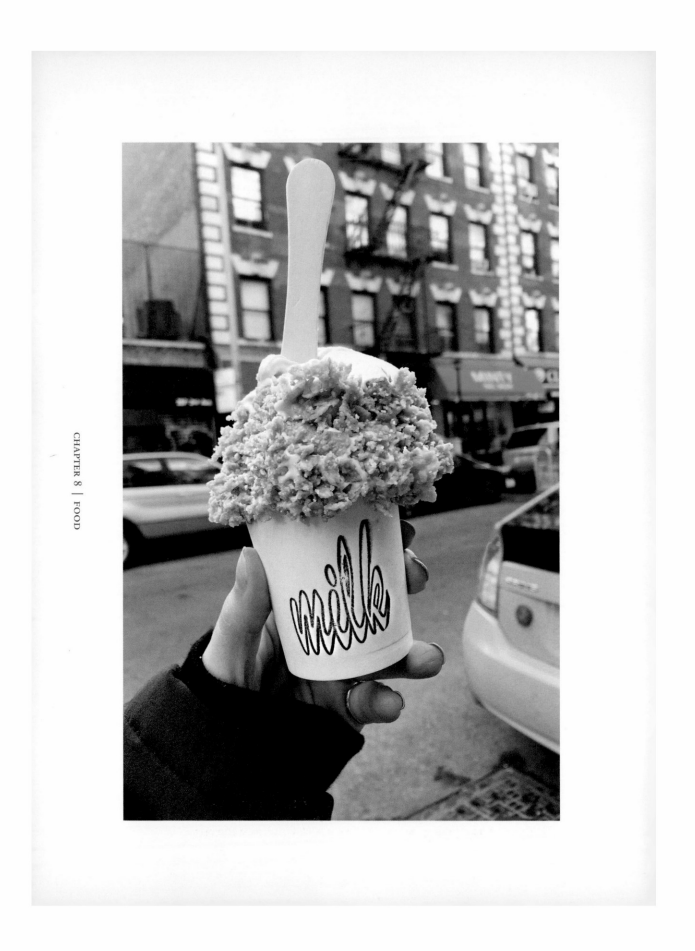

It's all about balance
– peace, love and pizza

My journey with food has definitely been a rollercoaster, but I should have listened to my mother from the start and eaten a bit of everything in moderation. I've finally learned to enjoy all sorts of food. I enjoy the way I feel when I eat a balanced diet and, as most of you will know, I basically eat whatever I want, whenever I want (within reason). For instance, I'm writing this paragraph on an airplane with a half-eaten chocolate bar beside me. I don't deprive myself, but I also don't let myself go off the deep end any more either. I try to remember that food exists to keep us nourished, while also enjoying the little things … like eating an entire box of cookies when I've had a stressful week.

I've realized that I deserve to feel good about myself and after everything I've gone through with food – the ups and the downs – I finally feel like I'm at a good place with it. I'm not so scared to try new foods and I don't binge eat to the point of feeling sick for days. When I do have a junk food marathon, I don't make myself feel guilty about it. Sometimes it's nice to not think about food in such a scientific way and just enjoy the damn doughnut!

Luckily, I've found different outlets to deal with stress, such as exercise, walking my dog, taking a bath or calling my best friend to vent. My best advice for someone struggling with food is to look inwards at yourself and try to understand what's really going on. I'm not a nutritionist or an expert, but I think most food-related issues are not about the food. Getting to this place was hard, but it is so much more sustainable to have a balanced lifestyle than following restrictive diets and feeling guilty about every little thing. I want to feel wonderful when I look in the mirror and I would never have been able to if I kept putting myself through hell. Be kind to your body, your mind and your soul. Peace, love and pizza.

Food is all around us, so if you keep your eyes open and you follow your nose you'll definitely run into something to satisfy your cravings. I'm really lucky because in London there are food markets everywhere that offer more than you could dream of! Fresh jams, spices, sauces, pastries and loads more. Walking through market stalls makes me excited to try out new recipes because everyone around me is also passionate about food.

Food ruts

Food ruts are real. I'm definitely a creature of habit when it comes to food, and I can be quite happy eating the same thing over and over again. I love canned soup, sandwiches and scrambled eggs, but it does get dull after a while. When I find myself being a bit bored by the foods I'm eating there are a few things I do to help.

1. I like to browse cookbooks (we collect them), which is a relaxing experience. Aslan and I often turn on some chilled music and look through our cookbooks as a way to unwind in the evening. Besides getting great recipe ideas, it also sparks loads of interesting conversations about travel, and our contrasting experiences with food.

2. Restaurants are wonderful, especially when you really take an interest in which places are buzzing in your city. For instance, I had never tried ramen until a couple of years ago and now it is one of my favourite food groups. That's right, ramen is a food group. Get out there! Get dressed up and try some new restaurants!

3. Instagram and social media are great ways to get inspired about food because there are so many people sharing their love for it. Whether you want very healthy dishes or very unhealthy junk food, there is some food porn on the Internet for you to drool over. Try to find a few people who have similar tastes to yours and see what and where they're eating.

4. Travel. Besides being forced to try new things in alien surroundings, I always love to think back on my travels and remember the food. The orange juice in Morocco, the hot dogs in Denmark, the kati rolls in India. All of the memories come flooding back every time I taste something similar, and it's always fun to try to recreate those meals at home.

5. Force your friends to cook. Dinner parties are not just for bored suburban yummy mummies, okay? I love having dinner parties (probably because Aslan does the cooking and I do the socialising). Throwing a dinner party is fun, but attending one is even better! I bet your friends will cook something you had no idea they could cook. Always leave with the recipe, if you like something.

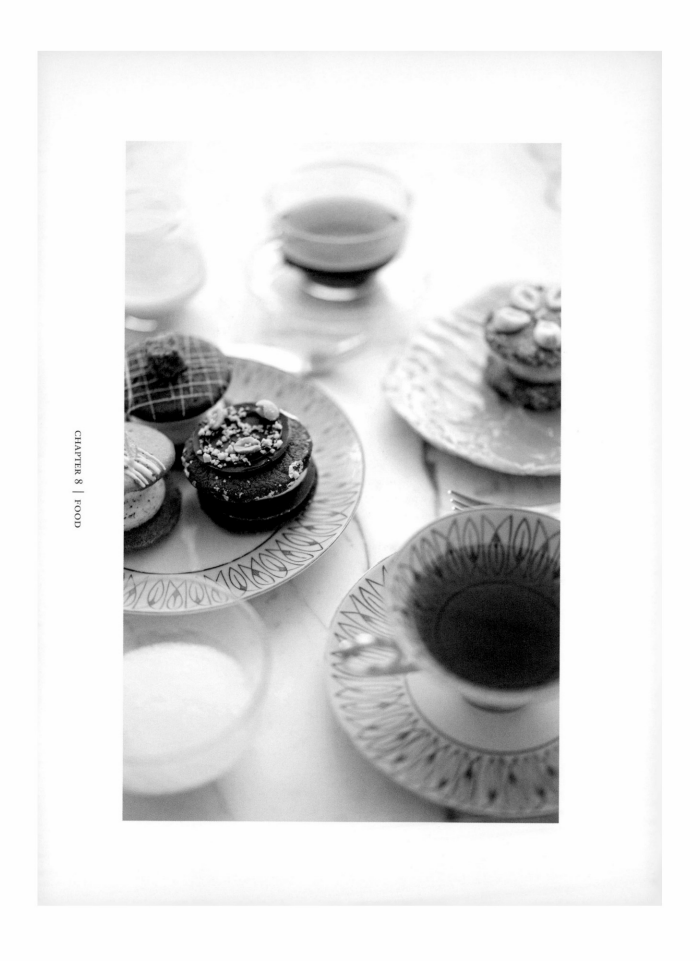

Tea time

I have an entire cupboard in my kitchen dedicated to tea, teapots and steeping devices. All tea drinkers will understand that half the joy of drinking a cup of tea is making it. I love seeing the hot water run over the leaves, watching the leaves expand as the tea steeps to become the perfect colour, pouring it from the pot into my favourite mug and, of course, that first sip. Oprah's phrase 'steep your soul' really hits the nail on the head for me! My daily tea-making ritual is my little bit of time to regroup. And tea always makes things better – difficult conversations can happen over tea, stressful work emails or phone calls are put into perspective with tea, relaxing afternoons always involve tea, and dinner isn't complete without an after-dinner mint tea.

Side note: tea is always made better with a biscuit.

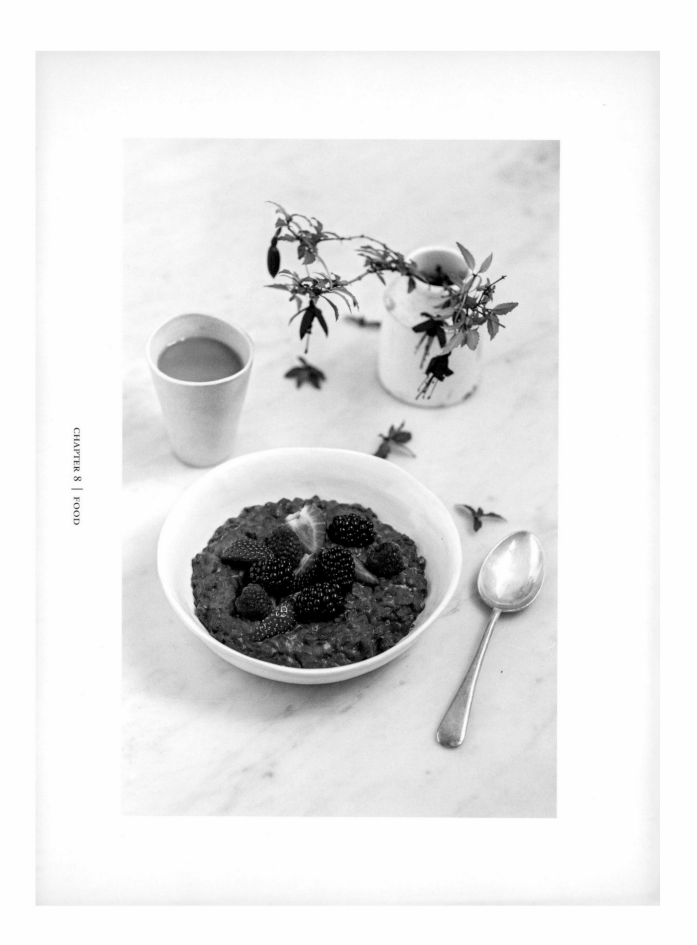

My favourite recipes

I feel like I've got a great relationship with food these days. I really want to learn how to cook better and I'd love to be a bit more adventurous when it comes to trying out new flavours. I'd also love to eventually have a garden of my own and grow my own vegetables. Watch this space! Here are some of my favourite recipes at the moment:

BREAKFAST

Cocoa porridge

I didn't think I liked porridge or oatmeal until I tried it with cocoa and nut butter, which changed my mind completely. This really fills me up and puts some gas in my tank to keep me going until lunch.

Serves 1

50g/2oz/½ cup porridge oats or rolled oats
250ml/8½fl oz/1 cup almond milk
2 tablespoons raw cacao powder
1 heaped tablespoon almond or peanut butter
pinch of salt
splash of coconut milk (optional)
fruit of your choice to serve (optional)

Pour the oats, almond milk, cocoa powder, nut butter and salt into a saucepan. If you like your porridge really creamy, add a splash of coconut milk. Bring the mixture

to the boil, then reduce the heat and simmer for 4–5
minutes, stirring continuously, until the nut butter has
melted and the porridge has thickened. Spoon into
a bowl and top with fruit if you like – I like to top
mine with mixed berries and banana slices.

Energizing stir-fry

I love making a stir-fry for lunch because it's quick and
we normally just chuck whatever vegetables we have
in the refrigerator in with some noodles and sweet chilli
sauce. It's so easy and flavourful.

Serves 2

groundnut oil, peanut oil or similar mild oil
1 garlic clove, finely chopped
1 thumb-size piece ginger, finely chopped
2 large handfuls of mixed vegetables (I like to
 use broccoli, spinach, baby and red peppers)
400g/14oz fresh rice noodles
sweet chilli sauce
generous splash of soy sauce

Heat the oil in a large wok, frying pan or skillet over
a high heat. When the oil is really hot, add the garlic
and ginger. Cook for 30 seconds before stirring in the
vegetables and noodles – keep everything moving while
it all sizzles and cooks through. After 4–5 minutes add
the sweet chilli sauce and soy sauce, and stir to coat
everything. Serve!

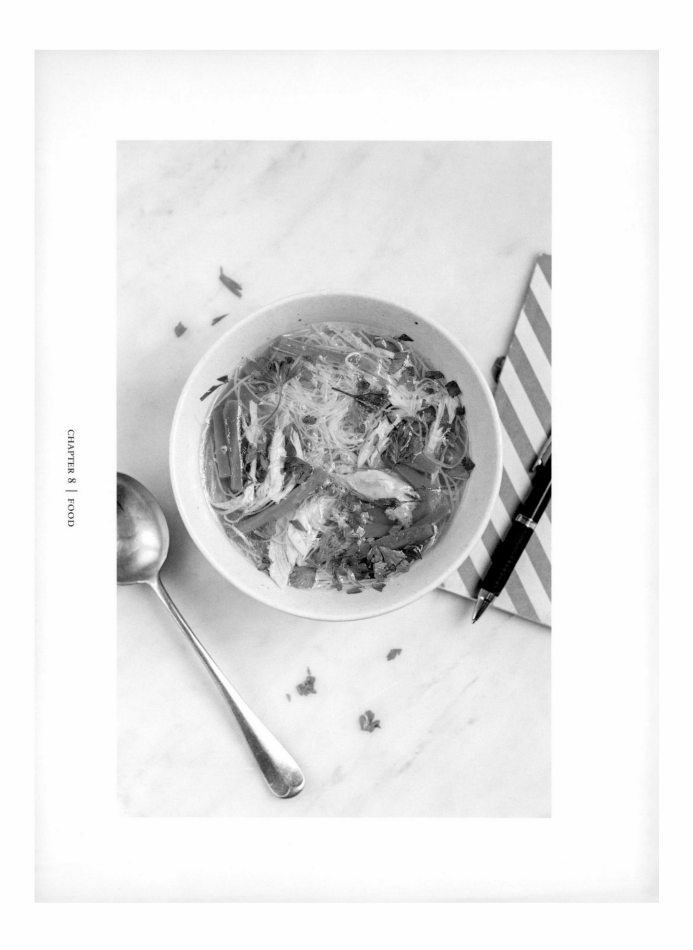

Aslan's chicken noodle soup

Chicken noodle soup warms the soul because it is made
with love. This isn't a quick recipe but I think it's worth
it if you're in need of a hug. Usually at the first signs
of illness Aslan will head off to the shop to get all of the
supplies necessary for this soup, which always makes
me smile. He's a good egg.

Serves 4–6

1 medium whole chicken
1 large onion, roughly chopped
2 garlic cloves, finely chopped
1 thumb-size piece ginger, chopped into matchsticks
1 bay leaf
2 carrots, chopped into matchsticks
100g/3½oz vermicelli noodles
fresh parsley, chopped (optional)
fresh dill, chopped (optional)
salt and freshly ground black pepper

Fill a very big lidded pot with enough water to generously
cover the chicken and bring to the boil. Carefully add the
chicken, onion, garlic, ginger and bay leaf, then turn the
heat down to a very gentle simmer. Season generously with
salt and pepper and give the whole thing good stir. Put the
lid on and leave to simmer for 2–3 hours.

Take the chicken out of the pot, place it in a large bowl
and cover. Strain the remaining stock into a large jug
or bowl and discard the veg.

Pour the strained stock back into the pot and bring
to a simmer. Add the carrots and cook for 10 minutes,
then add the vermicelli and cook for another 3 minutes.

While the carrots and vermicelli are simmering, get the
chicken ready; it should still be nice and warm, so be
careful handling it. Using a fork, take the meat off the
bone and shred it – it should be super tender and fall

off very easily. Discard the bones and skin. Once the vermicelli is cooked, add the chicken and leave it to stand for a couple minutes to warm the meat through.

Serve in big bowls topped with some chopped fresh parsley and/or dill, if using. Season with salt and pepper to taste.

DINNER

Pea and pancetta pasta

This is something Aslan and I always cook if we're in need of some carbs. This was the first meal he ever cooked for me when I moved to England, so it has a really soft spot in my heart. Carbs are so dreamy.

Serves 2

1 tablespoon mild olive oil or vegetable oil
1 small onion, finely chopped
1 garlic clove, crushed
1 red chilli, seeds removed and finely chopped (add more
 or less depending on how much heat you can take)
200g/7oz dried spaghetti
80g/3oz diced pancetta
50g/2oz/⅓ cup frozen peas
2 egg yolks
50g/2oz/⅔ cup grated parmesan, plus extra to serve
freshly ground black pepper

Bring a medium saucepan of water to the boil. Heat the oil in a frying pan or skillet and add the onion, garlic and chilli. Cook over a low heat for about 5 minutes until softened.

While the onion mixture is cooking, put the spaghetti into the pan of boiling water and cook according to the packet instructions – usually for about 10 minutes – until it's soft but still has some bite.

Add the pancetta to the onion mixture and cook for a further 5 minutes or until the pancetta is cooked through. Add the frozen peas and cook for about 1 minute.

When the spaghetti is nearly done (about 2 minutes left to go), in a bowl beat together the egg yolks, parmesan and some black pepper using a fork. Drain the spaghetti and put it back into the hot saucepan. Add the onion and pancetta mixture, then the egg mixture, and stir everything together – the hot spaghetti will cook the raw egg and create a creamy cheesy sauce. Serve topped with more grated parmesan.

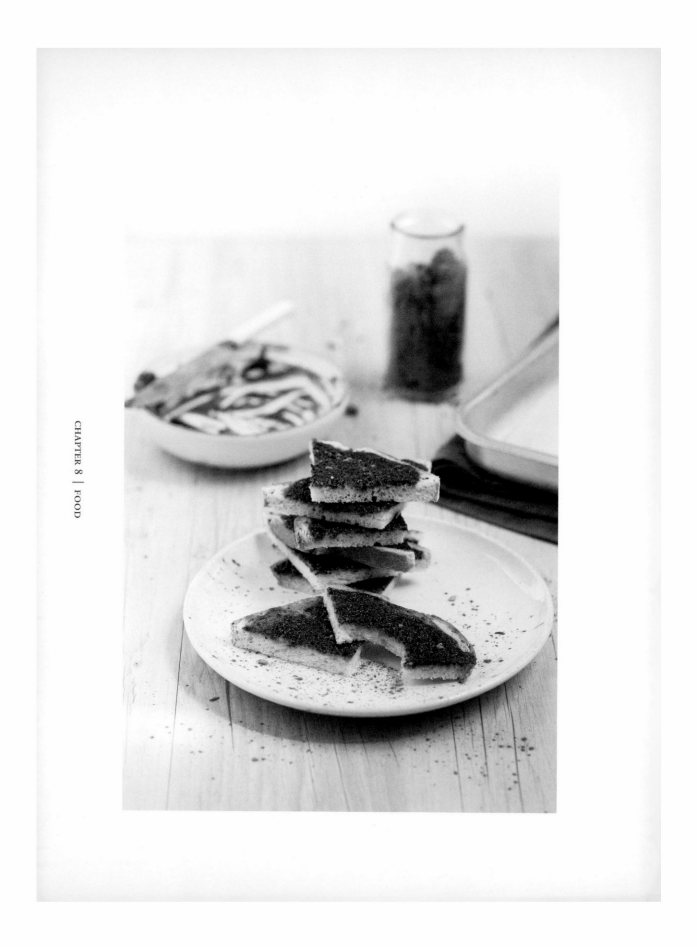

Ultimate cinnamon toast

This is my ultimate cinnamon toast recipe. It's really easy and quick. The first bite of this toast will make you die and go to heaven, the second bite will confirm that you are indeed in heaven.

 55g/2oz/4 tablespoons salted butter
 2½ tablespoons brown sugar
 1 teaspoon ground cinnamon
 1 teaspoon vanilla extract
 2 slices of whatever bread is in the house
 (my favourite for this recipe is white bread)

Preheat the oven to 180°C/350°F/gas mark 4. In a bowl, beat together the butter, brown sugar, cinnamon and vanilla extract until it's the consistency of a creamy dough – don't over mix it otherwise it will get too runny.

Spread the mixture evenly across the slices of bread – it will look like a lot but don't be scared, embrace it! – and then pop the bread into the oven for about 10 minutes or until the top is crispy and bubbling.

Devour!

Strong

As someone with an appetite that is never satisfied, exercising and feeling physically fit are things I've come to love. I no longer look at working out as a chore and I genuinely look forward to getting my sweat on in the gym. There is no greater stress reliever than popping on your favourite Beyoncé tune and jogging along to the beat.

Working out is my chance to escape and feel powerful. It's so satisfying to have a good workout and, while I'm definitely NOT the fittest girl in the world, I like to keep track of my personal bests. I'm not in competition with anyone at the gym, no one is looking at me and it's something I do only for myself.

At the end of the day, your body is a machine. It has a lot of functions to perform and getting into fitness more has made me much more in tune to the way my body works. For instance, I know my left hip clicks if I don't engage my abs properly while doing a sit-up. Learning things about my body has helped me walk taller and fully realize that every part of me is working together to make movements. The more I get to know my body, the more I respect it and the foods I put inside it.

Working out is actually quite a personal part of my week because it gives me time to reflect, set fitness goals for myself and hopefully achieve them. I try my best to get into the gym three to four times per week. It's not always possible with my schedule, but I try.

Much like my attitude towards food, I don't get angry at myself if I miss a session. If I'm really busy or simply just too tired, I don't work out. I want working out to remain something I enjoy, and if I put too much pressure on myself I will start to hate it.

It's also fun to try out different types of fitness classes to see what you're into. I never in a million years thought I would enjoy going to a spinning class, but there's something really engaging about everyone in the room cycling to the beat. I also love kickboxing, Pilates and weights. Strong body, strong mind.

Afterword

Writing this book helped me reflect on a lot of past memories and experiences that I have previously pushed aside and ignored. On top of actually writing this book – which was hard work! – it was difficult to rustle up those old memories (and demons) and remember how I felt at the time and then work out what lessons I learned. I don't often like to think back on old memories (good and bad), partly because I get too nostalgic, but doing so has been rewarding. The process has taught me so much about myself, and the progress I have made up to now.

If writing this book has taught me anything it's that I have a lot to look forward to and to be grateful for. I am so lucky to be surrounded by love and support, which has always carried me through. So many things happen in a very short amount of time and taking the time to digest my journey so far has been a wonderful gift.

So, now you've read my story, I throw out the challenge to you to think about yours. What has made you who you are today and where will life take you next? I want to hear all about what has made you bloom and what's important to you.

Index

Acknowledgements

First and foremost I have to thank my outstanding viewers who have given me so much encouragement and support over the years. If someone showed me a snapshot of my life when I was little I never would have believed it. To everyone who watches, shares and comments on my YouTube videos and supports me, thank you. Thank you from the bottom of my heart for getting me to this place, I appreciate it more than words can express.

Of course I have to thank my family. We really get each other.

Without Aslan none of this would have been possible because he is not only my soul mate, but he is also my IT and photography teacher and all round pillar of strength!

Thank you to the team at Storm and, specifically, my manager, Emily. She is the absolute best. I adore working with her and it's so comforting to know that someone else shares my vision! Thank you for never thinking I'm overreacting (although usually I most definitely am). And I can't forget to thank Lou who played a huge part in getting this book off the ground!

Thank you to Colm and Imagist for the beautiful page design – you exceeded all my expectations. And to Two Associates for the gorgeous cover design. Last but not least, thank you to everyone at Ebury who believed in this book and tirelessly worked on making Bloom the best it could be – especially my editor, Laura, who had to deal with my day-to-day meltdowns.

10 9 8 7 6 5 4 3 2 1

Ebury Press, an imprint of Ebury Publishing,
20 Vauxhall Bridge Road, London SW1V 2SA

Ebury Press is part of the Penguin Random House
group of companies whose addresses can be found
at global.penguinrandomhouse.com

Penguin
Random House
UK

Copyright © Estée Lalonde 2016

Photography on pages 2, 6, 38, 64 © George Muncey 2016;
Photograph on page 35 © Rankin/Trunk Archive 2016;
All other photography © Estée Lalonde

Estée Lalonde has asserted her right
to be identified as the author of this
Work in accordance with the Copyright,
Designs and Patents Act 1988

www.penguin.co.uk

A CIP catalogue record for this book
is available from the British Library

Design: Imagist

ISBN 9781785033650

Colour origination by Rhapsody Ltd, London
Printed and bound in Italy by Printer Trento

MIX
Paper from
responsible sources
FSC® C018179

Penguin Random House is committed to a sustainable
future for our business, our readers and our planet.
This book is made from Forest Stewardship
Council® certified paper.